# ALEK RAPOPORT

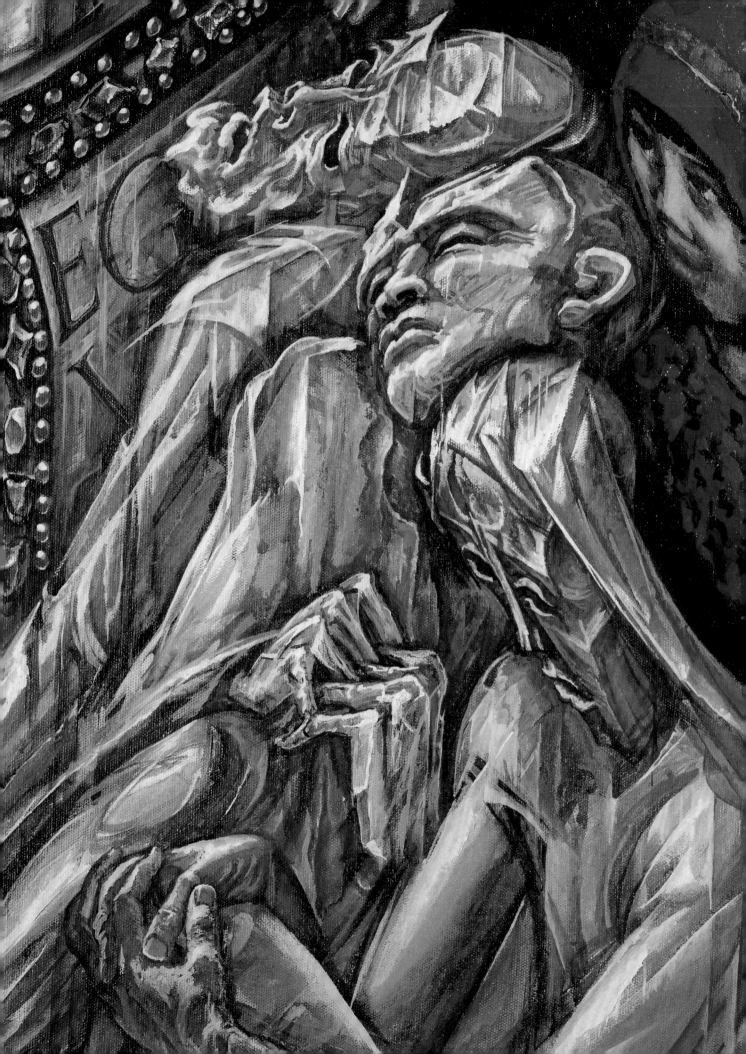

# ALEK RAPOPORT

## AN ARTIST'S JOURNEY

MICHAEL DUNEV GALLERY

# CREDITS

| | |
|---|---|
| Contributors: | Michael Dunev<br>Director, Michael Dunev Gallery, San Francisco, California |
| | Michael P. Mezzatesta<br>Director, The Duke University Museum of Art, Duke University,<br>Durham, North Carolina |
| | Alla Rosenfeld<br>Curator of Russian and Soviet Art, Jane Voorhees Zimmerli<br>Art Museum, Rutgers, The State University of New Jersey,<br>New Brunswick, New Jersey |
| | John E. Bowlt<br>Professor of Slavic Languages and Literatures, University of<br>Southern California, Los Angeles, California, and Director, The<br>Institute of Modern Russian Culture at Blue Lagoon,<br>Los Angeles, California |
| Translators: | Paul Bannes<br>Elizabeth Bishop<br>Elena Shumskaya |
| Photography: | Donald Felson (pp. 2, 20-24, 27, 34-37, 45,  51-73, 77-108, 114)<br>Jock McDonald (p. 6)<br>G. Prikhod'ko (p. 15)<br>D. Kirillov (p. 122) |
| Book Design: | Michael Dunev |
| Printer: | Sung In Printing Company, Seoul, South Korea |
| Publisher: | The Michael Dunev Gallery<br>660 Mission Street, San Francisco, California 94105<br>Telephone  415 284 9851<br>© 1998  All rights reserved |

Library of Congress Catalog Number: 97-094533
ISBN: 0-9661190-0-2

Cover: **Girlfriends**
Mixed media on masonite, 1994 (detail), 48 x 108 in; 122 x 274.3 cm. Collection of the estate

# CONTENTS

*I have always been a realist. I am a realist because I am concerned with what is real in life; that is what I depict.*

A. Rapoport, 1993

# FOREWORD
Michael Dunev

When I first met the diminutive Russian émigré sometime in 1985, I was struck by the honest intensity of this man, so small in stature yet so great of presence. Although his work was unknown in San Francisco and hardly consistent with the aesthetic or philosophical direction of my gallery, the sincerity of his personality and the power of his remarkable paintings impelled me to present his work as a testament to art's ability to survive all hardship and tribulation.

In Russia Alek had rejected from the outset the prescribed "social realism" of the Soviet regime, immersing himself in his Jewish heritage and seeking to create in his work a spiritual union between the Russian avant-garde and the devotional works of Byzantium. A seminal member of TEV, ALEF and other dissident art organizations in Leningrad, Alek faced stiff opposition from the authorities who accused him of "formalistic distortion, ideological sabotage" and of producing "religious, fascist and Zionist" art. Despite achieving significant critical success in the underground art community, Alek could only exhibit clandestinely. Seeking integration with the international art world, he emigrated with his family in 1976, leaving behind hundreds of paintings whose export had been prohibited by the authorities. These works he would never see again.

In 1977 Alek arrived in San Francisco, a city known for its liberal attitudes, its cosmopolitan heterodoxy, its large artistic community and its considerable Russian émigré population. His disappointments in the Soviet Union and the discrimination which he suffered because of his officially undesirable art style led to great hopes that once settled in the West, he might enter the mainstream of contemporary art and receive the recognition that in Russia had been denied.

Yet California, with its attachment to a "home grown" culture, was slow to accept his work. Those powerful expressionistic paintings, with their warped and elongated figures, were more in line with El Greco, Goya and Andrei Rublev's icons than the light-drenched canvases of Diebenkorn, Thiebaud or Francis. Despite his enthusiasm for California's Mediterranean light and its diverse ethnic mix, Alek Rapoport remained outside the mainstream of the Bay Area contemporary art scene. A loner, Alek remained a dissident in San Francisco, as he had been in Russia.

Alek's role as an outsider was primarily due to his unwillingness to compromise the integrity of his vision to the fashion whims of a fickle art market. He refused to adopt tendentious or politically correct postures in order to please trendy art critics and curators, painting instead about conscience, about alienation in a materialistic world and the dialogue between the soul and the creative spirit. A man of remarkable resiliency, Alek gathered strength from

adversity and resolve in his convictions, quietly pursuing his dream, confident in the truth of his vision, and creating an extraordinary body of work. Although exhibiting actively in venues around the country, Alek lived in poverty, and in the end, worked entirely for himself, impervious to the vagaries of the market and to the ebb and flow of artworld trends.

Characterized by forced perspectives and a vertiginous sense of motion, the highly textured surfaces and rich impasto of Rapoport's paintings have a style which is uniquely their own. At once modern and archaic, the work is a product of professional training in Theater Design and a long and lasting interest in the history of Western painting.

Thematically divided into religious and secular subjects, the paintings of Alek Rapoport are windows into the very personal world of an artist who was driven by the belief that art serves a higher purpose. Inspired by the frescoes of Giotto and the devotional icons of the Russian Orthodox church, Alek's religious work integrates Judaism with New Testament Christianity, and resonates with the profound spirituality of the Renaissance masters. Although nearly anachronistic in style and subject matter, his paintings have a bite to them, an edge so sharp, that one cannot help but be moved by the sincerity of their effort. They emerge from a deep wellspring of passion; that Man is the measure of all things and that the Holy Spirit is the guiding force of all creative endeavour.

Alek's ongoing Images of San Francisco are observations of an artist who functioned independently from the hustle and bustle of the city in which he lived. His choice of subjects, the alienated and the dispossessed, the quaint and the obscure, are outsiders to the mainstream, a mirroring perhaps, of Alek's own world. Yet despite his identification with those marginalized by society, his Images of San Francisco chronicle the ethnic diversity and the life of a city with the detached perspective of an entomologist peering into an ant farm.

The paradox reflected in these paintings seem to echo the contradictions in the life of a man who fought for freedom of expression, championing the revolutionary cause of the Constructivists and Suprematists while turning for inspiration to mediaeval art and the two thousand year-old writings of the evangelists. But artists are not people easily understood. While he was loved and admired by those who knew him, to many he remained an enigma, an anachronism, an incomprehensible mystery.

It is my genuine hope that this book will contribute to the understanding of this man's extraordinary work, and that it will help provide some answers to the fundamental questions raised by his remarkable paintings. I wish to thank Michael Mezzatesta for his thoughful and significant writing and for the sincere enthusiasm he shares for Alek's work. I also thank Alla Rosenfeld for her important essay on Alek's formative years and the significance of his dissident activities in pre-Perestroika Russian art. John Bowlt's insightful critique goes a long way to clarifying the psychological themes that pervade throughout Alek's work, and I am deeply grateful for his meaningful contribution. I wish thank Carlos Loarca for his generosity of spirit, and to acknowledge with gratitude the patient work of the collectors, translators, photographers and the many others who contributed to this work. But most importantly, my appreciation goes to the tireless dedication, work and support of Irina Rapoport, without whose invaluable assistance none of this would have been possible.

# INTRODUCTION
Michael P. Mezzatesta

*Nowadays, when shoe boxes are adorned with reproductions of the Mona Lisa and Marc Chagall's work serves as decoration for bed linen, a voice must be raised in defense of the artist and his place in society.*

*The purchase of paintings as investments; buying "name artists;" the exploitation of paintings as interior decoration (where the matte and the frame are more important than the painting)...*
*these all deny the spiritual content of art not only for the buyer, but for the artist. This kind of distortion of the purpose of art is no less dangerous than putting art at the service of totalitarianism.*

A. Rapoport, 1981

A monumental shaped canvas in the form of the disembodied head and hand of the Old Testament prophet Mordecai represents one of Alek Rapoport's most powerful paintings. With his hoary emaciated face, full beard, fiery eyes, furrowed yellow brow and gaping red mouth screaming "a loud and bitter cry" (Esther 4:1) that pierces the air like the wail of a siren, Mordecai warns his people of the danger to their lives and religion. This startlingly powerful head forces itself into our physical and psychological space by its sheer size, high relief, jarring colors and by its terrifying dramatic intensity. Mordecai's disquieting presence is as alarming as his shouted warning — and so it should be, for a prophet is unpleasant to be near and his message never sugar coated but blunt and alarming. Perhaps not surprisingly to those people who knew Alek Rapoport, the painting's title is itself revelatory. *Self-portrait as Mask of Mordecai*, represents a spiritual self portrait of the artist as well as a summa of his life and philosophy. It stands as a powerful emblem of a man dedicated to an uncompromising search for that elusive and ever shifting essence that provides both solace and meaning to our lives.

His life began in Kharkov, in the Ukraine, in 1933 at the beginning of Stalin's purges. Alla Rosenfeld has chronicled that period of his life in her essay on Rapoport in Russia, *The Artist Who Refused to Compromise: Alek Rapoport's 'Russian Years'*. As she has noted, these years provided the foundation for his artistic training and were the time when he discovered and sought to explore his Jewish heritage in his art. Ms. Rosenfeld succinctly summarizes his seminal role in the formation of several underground groups of Jewish artists and their struggle to exhibit. Intense official repression forced Rapoport, and many other artists, to leave the Soviet Union. In 1977 he settled in San Francisco where he lived with his family until his untimely death in February of this year.

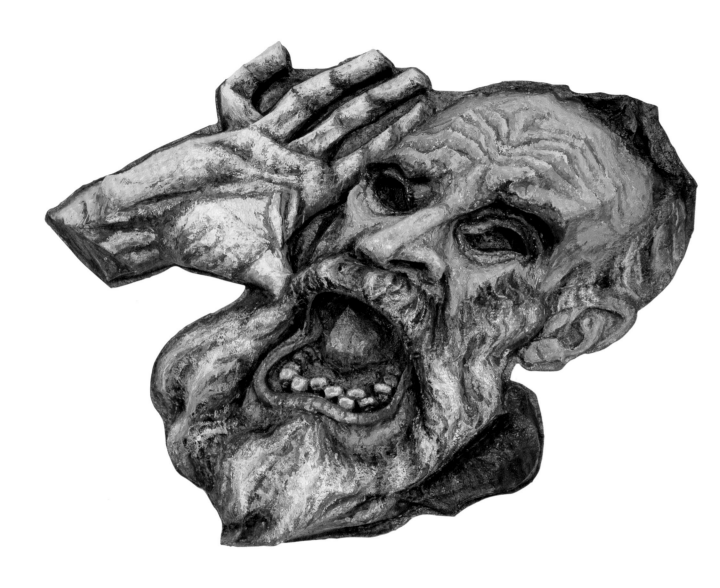

**Self-portrait as Mask of Mordecai**
(Esther 4:1)
Mixed media, relief on packing board, 1989
58 x 76 1/2 x 12 in; 147.5 x 194.5 x 30.5 cm.
Collection Duke University Museum of Art,
Durham, NC

Right up to his death, Rapoport continued to explore the relationship between art and the roots of western culture in Greek myths and especially the Old and New Testaments, sources rarely drawn upon by contemporary artists. In his essay, John Bowlt has analyzed the intellectual roots of that search in Russian culture, roots which he traces from the artist through his teachers back to the leaders of the avant-garde and beyond to its origins in the Mediterranean's cradles of civilization. Bowlt has identified a central concern of the artist: the chasm between the crass materialism of the modern world and man's spiritual needs. The artist was disturbed by what he saw as the spiritual poverty and materialism of American life and the crass commercialism of the western art market. At the same time, as Bowlt perceptively points out, Rapoport was an acute observer of the San Francisco scene, not as a mere genre painter but as studied as an observer through the lens of his philosophical and metaphysical magnifying glass. Even in these images of the streets and characters of San Francisco, his work attempted to reestablish a meaningful role for art by creating a link to what he saw as the wellspring of our culture.

In this sense, *Self-portrait as Mask of Mordecai* is as much a cry in defense of art as a Biblical allusion. Just as the prophet refused to bow down before Haman, the enemy of his people, so too the artist must refuse to compromise his principles before the altar of commercialism.

Similarly, in two other paintings completed shortly before his passing, *The Three Deeds of Moses* (p. 59) and *Lamentation and Mourning and Woe* (p. 55), Rapoport continued the admonitory tone of the *Mask of Mordecai*. Rapoport's use of rapid, expressive brush strokes, his bold handling of color and paint, and the angular distortion of the figures which recall Russian icons conveys a timeless urgency to the compositions. In the former, an angry Moses appears like a tornado, a whirlwind of rage with drapery swirling tumultuously around his contorted body as he smashes the tablets of the law, hurls down the golden calf, and orders the death of the apostates (Exodus 32:27). Rapoport noted that Moses was not a "fine gentleman" and that he used harsh measures to reform the stiff-necked children of Israel: "*Moses's acts are very telling in our time of total permissiveness, relativism and indifference.*" In the latter, inspired by a passage from the Book of Ezekiel (2:9), a glowering angel with huge outspread wings and sword held high hovers threateningly over the cowering prophet. The stern message from the Lord to the rebellious Israelites was of lamentation and mourning and woe should they not heed God's warning. Ezekiel, the man made prophet, carried that admonition to his people so as to reform their transgressions. In a world which Alek Rapoport knew as harsh, unfriendly and fraught with danger to body and spirit, he painted an angel and prophet imbued with the electrifying promise of regeneration. As the artist noted, "*In fact, each work of art ought to carry out a "miracle" of transformation and amelioration of the perceiver.*"

Alek Rapoport was an artist and a philosopher. One cannot fully appreciate the complexity and richness of his thought without experiencing his writings as well. Toward that end, there have been assembled in this book by his wife Irina, statements on art which cover nearly two decades. Together with his paintings, they offer a powerful introduction to a man whose heart and mind expanded over a lifetime, one often marked by disappointment, persecution, rejection and anger at the state of art in the modern world, to embrace the great historical and spiritual panorama of our cultural origins and who in the process, I suspect, found that elusive peace of mind that only deep self knowldege can afford.

## AN ARTIST WHO REFUSED TO COMPROMISE:
## ALEK RAPOPORT'S 'RUSSIAN YEARS'

Alla Rosenfeld

In *A Poem of the End*, Marina Tsvetaeva wrote in 1924, "In this most Christian of worlds, all poets are kikes."[1] In 1991, Alek Rapoport in his unpublished notes, as if repeating this thought of Tsvetaeva, stated: "...an artist belongs not only to his ethnic tribe but also to a special tribe-artistic... ."[2] All of Rapoport's works, although often based on Jewish themes, deal with universal concepts and concerns. Having emigrated to San Francisco from Leningrad (Russia) in 1977, Rapoport remained an outsider, just as he had been when he started the group of Jewish artists (ALEF) in the 1970s in Russia. Jewish artist, he died while working on the work with such a Christian title — *Trinity*.

In 1937, by the time Rapoport was four years old, both of his parents had been arrested during Stalin's purges. His father was shot in 1939 and his mother spent ten years in a Siberian labor camp for some unknown "crimes against the state." The first criticism of Rapoport's art came at an early age in the form of a furious remark made by the postal censor who was checking the letters that Alek was sending to his mother. The postal censor wrote a note to Alek's aunt (with whom the boy lived at the time): "You should not allow your boy to draw portraits of the Communist Party leaders; he distorts them."[3] Soon after the beginning of the World War II, Rapoport was evacuated to Ufa, Bashkiria. While there, he frequented the local art museum and soon turned to drawing.

After the end of the war, Alek lived in Chernovtsy, Ukraine, where he started taking art classes at the House of Popular Art. His first teacher was Evgenii Sagaidachny, a former member of the two important avant-garde artistic groups of the 1910s, Union of Youth and Donkey's Tail. Another teacher, Irina Beklemisheva, recommended that Rapoport go to Leningrad to study.

In 1950, following Beklemisheva's advice, Rapoport entered the Tavricheskaia Art School (presently the Serov Art School) in Leningrad, an old, well-established, and highly prestigious art instition in Russia. Formerly known (after 1857) as the Drawing School of the Society for the Encouragement of the Arts , it was regarded as one of the most democratic art schools in 19th-century Russia because it allowed any individual interested in the arts, regardless of his class background, to study there, going as far as even including women among its students. Many famous late 19th- and early 20th-century Russian artists were associated with this school, including such prominent artists as Ivan Shishkin, Ilya Repin, Vasillii Surikov, and Mikhail Vrubel, among others. At the beginning of the 20th century, the artist Nikolai Roerich served as the school's director. Despite the hunger, poverty, and severe devastation that followed the Bolshevik Revolution of 1917, the school continued to function. During World War II, in 1943, immediately after the end of the 900-day's seige of Leningrad, the drawing classes were held in between air-raid alarms. The school provided a very strong professional art education, with a serious concentration on drawing. However, it was an extremely traditional and conservative school when Rapoport was a student there in the 1950s and '60s, not allowing any freedom of artistic expression to its students. Some teachers at the school, including Ya. K. Shablovsky, V. M. Sudakov, and A.A. Gromov, were former "formalists" who secretly helped their favorite pupils become familiar

with major avant-garde movements of the 1910s and 1920s, which were prohibited and considered "formalist" and "decadent." In 1968, the school was named after V.A. Serov, who was President of the Academy of the Fine Arts of the USSR between 1962 and 1968. It was Serov, an agressive and uncompromising Socialist Realist artist, who once stated: "Abstract art is not a form, it's ideology."

Rapoport studied in the pedagogical department where future art teachers were trained. During those years, he spent much time at the Hermitage Museum copying Old Masters and Western modernists such as Paul Cézanne and Georges Rouault, while also looking through the art books at the Academy of Fine Arts research library, and studying prints at the print department of the State Public Library. At the time, he was most influenced by the work of Cézanne and Rouault, as well as by the work of Petr Konchalovsky (1876-1956) and Ilya Mashkov (1881-1944), the members of the Jack of Diamonds group, also known as the "Russian Cézannists." Rapoport's painting, *Boys in the Hermitage Museum*,1960, with its unusual perspective, fragmented elements, and curiously flattened and ambiguous space reflects his early admiration for cubist art.

Rapoport, with his strong interest in various modernist trends, did not fit well in the system of traditional education and the art establishment, constantly having problems with art school authorities, and as a result, he was suddenly drafted into the Soviet Army in 1954. It was a rare case, since he was already a final-year student (while at school, students were usually protected from being drafted). Returning from the army in 1957, he completed his diploma

work, *Laying the Wreaths on the Field of Mars*, 1958 (Museum of the City of Leningrad), which created a scandal at school and was proclaimed "formalistic" by the school's administration for its almost constructivist treatment of the figures. The anatomies of the figures, which look like solid geometric blocks, are defined by jagged planes that lacerate torsos and limbs in violent, unpredictable patterns. The most immediate quality of the work is a barbaric, dissonant power. Rapoport's insistence on lucid, elementary shapes and the work's architectural clarity and monumentality, as well as its ascetic exactitude, also suggest the possible impact of the Soviet Severe Style artists.

Graduating with a BFA in 1958, Alek sought to continue his art studies. He first applied to the Mukhina School of Industrial Arts, and then to the Academy of Fine Arts, but was failed at the entrance exams in both places since at that time, due to strong anti-Semitic sentiments in Soviet society, it was extremely difficult for a Jew to become a student at one of these top art schools. Rapoport's passport indicated his Soviet citizenship but listed his nationality as Jewish.

Geometric Self-portrait
Oil on canvas, 1958
Dimensions and whereabouts unknown

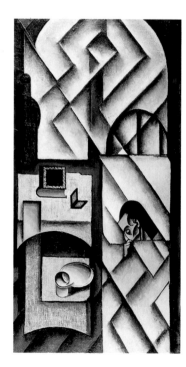

Cancer Patient
Oil on canvas, 1958
29 3/4 x 15 3/8 in; 75.5 x 39 cm.
Whereabouts unknown

Jews in the Soviet Union were recognized not as a religious group but as comprising a nationality — equivalent to, for example, Ukrainian or Georgian — and to this day are considered a people distinct from Russians. Unlike Western countries where one could be, for example, a French Jew or an American Jew, in the Soviet Union one could not be Jewish and Russian.

Rapoport did not abandon his desire for further professional training in the arts, and showed his works to N.P. Akimov, Professor at the Leningrad State Institute of Theater, Music and Cinema, who was known for accepting in his class talented students expelled from other art schools for their nonconformist dissident views. Akimov regarded Rapoport's work quite highly and immediately accepted him into his stage design department at the Institute. Rapoport always considered Akimov the most liberal and democratic of all of his teachers. Akimov was not afraid of any "isms," allowing each of his students to experiment freely with any of the modernist styles. Rapoport's *Geometric Self-portrait* and *Cancer Patient*, both painted in 1958, present a monumental contrast of curved and straight planes and silhouettes. These works are exemplary of Rapoport's art at the beginning of his creative career, when he was strongly influenced by Cubism and Constructivism. However, his interpretation of Cubism was not unique, for it was shared by many other Russian nonconformist artists of the time.

In 1965, Rapoport returned to the Serov Art School, this time as a teacher. When he protested against the rigidity of the system of teaching there, and was caught showing some reproductions of works by Western modernists to his students, he was accused of "ideological sabotage" and fired. From 1963 to 1973, he also worked as a graphic designer for various publishing houses and as a stage designer for theaters and film studios. Among his most important work for the theater were costume and stage designs for Isaak Babel's *Sunset*, created in a form of high relief with many layers of paint. His work on Babel's characters eventually evolved into a whole graphic series depicting Jewish personages from a bygone era. These pen and ink and charcoal drawings showed ordinary Jewish people, inhabitants of prerevolutionary shtetl, in a style closely connected with old traditions of folk art culture and reminiscent of the work of Anatolii Kaplan, an artist whom Rapoport regarded highly. These works, such as *A Bride*, *An Old Man*, *Talmudic Scholars*, *Rabbi*, and *Musicians*, were intended as portrait-types. Later, Rapoport would develop lithographs and etchings with similar characters.

Growing up in the anti-religious and particularly anti-Zionist environment of the Soviet Union, Rapoport did not have a good opportunity to become well-informed about Judaism. The national policy of the Communist Party, set against

"cosmopolitans" and advocates of ethnic development, resulted in the cessation of a visible Jewish culture in the USSR. In 1952, Stalin concoted the Doctor's plot, in which he accused nine doctors (six of them Jews) of planning to murder Communist leaders. After that time, Jewish life and identity became underground phenomena. However, being highly interested in Jewish culture, Rapoport studied the Old and New Testaments and traveled extensively throughout western Ukraine and the south of Russia, visiting old synagogues and making numerous drawings at the various Jewish cemeteries. Rapoport's fascination with Jewish tombstones, synagogue ornamentation, and the works of Jewish primitives, served as his material while he worked on his religious paintings, and helped him to discover his "national identity."

Rapoport's religious beliefs were a mixture of the Byzantine form of Christianity and Judaism, and he was equally interested in Russian Orthodox icons and Jewish folk art. In his unpublished essay, *ALEF Group as an Offspring of Russian Judeo-Christian Traditions*,[4] he wrote: "There were entire regions and whole Russian and Ukrainian villages that adopted and observed Judaism. Peasants from these villages called themselves Jews and shared all hardships with real Jews. The authorities scornfully called them *zhidovstvuiushchie*.[5] From the end of the 19th century, the same sobriquet was given to a certain group of Russian intellectuals. They were ethnic Russians who somehow behaved like Jews, had Jewish friends, married Jews, defended Jews, etc. One could perhaps link the late Academician Andrei Sakharov to this group. Another group was given the disparaging name *khristianstvuiushchie*.[6] They were ethnic Jews who wholeheartedly shared and fostered the best traditional Russian cultural and religious values. Poets Osip Mandelstam and Joseph Brodsky, bard Alexander Galich, and the Russian Orthodox priest Alexander Men' can be included in this group. Undoubtedly, the whole history of Jewish intellectuals in Russia has been the history of the bearing of the crosses of their intellectualism and their Jewishness..."

**Three Figures**
Tempera, oil & relief on pressboard, 1966
72 x 48 in; 183 x 123 cm.
Coll. A. Chudnovsky, St. Petersburg

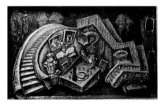

**Sunset**
Mixed media on masonite, 1963
Set design for play by I. Babel
Dimensions and
whereabouts unknown

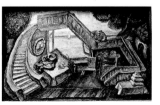

**Sunset**
Mixed media on masonite, 1963
Set design for play by I. Babel
Dimensions and
whereabouts unknown

15

While still living in Russia in the 1960s and early 1970s, Rapoport created a number of religious paintings, embracing both Jewish and Christian themes; he felt that the two religions enriched and enhanced one another. Always believing strongly that art should address questions of high moral significance, he turned often to biblical themes, approaching them from historical and psychological points of view. Deviating from the traditional approach to religious themes, he sought to portray the fate of modern Jewry and doing so interpreted the events in religious history as metaphors for situations with which contemporary man was confronted: suffering, doubt, yearning, and death. He tried to recreate the Jewish artistic inheritance in national forms, while also expressing the accomplishments of modern art. The titles of his works speak for themselves: *The Trumpet of Jericho, Prophet, Daniel*. In *Three Figures*, 1966, he depicts the passion of the prophets, highly exaggerating and distorting their figures and faces. Prophets were major figures in the Old Testament who upheld the Old Law and delivered God's message to man. They were the religious leaders of Israel, whose task it was to purify and reform the life of their people. In traditional art, the prophets were usually depicted

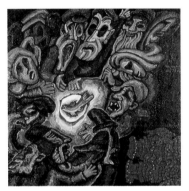

**Evening Meal**
Oil on canvas, 1975
52 x 52 in; 133 x 133 cm.
Coll. J. V. Zimmerli Museum, Rutgers University

as majestic, idealized figures of great dignity. In Rapoport's work, the primitive power of form is fully complemented by the magnetic expression of the prophets' heads. It is exactly this freedom in the exploration of mass and void, line and plane, color and value that makes this work so expressive. Rapoport used Russian Orthodox icons and frescoes as his models for grotesque simplification in the rendition of human forms, which is also evident in his other works, for example, *Isaiah* Diptych, 1975, where the artist contrasted the despair of Divine Judgment to the joy of Divine Favor. In *Evening Meal*, 1975 (Zimmerli Art Museum, Rutgers University), Rapoport metaphorically interpreted the theme of the Last Supper, showing a group of monstrous characters crowded around a table on which was placed a plate with a fish. In early Christian art the symbol of the Eucharist on the table is the fish; therefore the work takes on a biblical meaning, although its characters look like present-day Soviet inhabitants.

Rapoport combined his teaching work and theater design projects with painting, eventually joining a nonconformist movement of Leningrad artists, and taking part in all of the major unofficial exhibitions of the time. He belonged to the *barachniki*[7] generation of Leningrad artists, together with other artists as Aleksandr Arefiev, Rikhard Vasmi, Sholom Shvarts, and Vladimir Shagin. These artists often depicted in their work the depressing nature of everyday existence in the Soviet Union.

Rapoport became a member of TEV (Association of Experimental Exhibitions), a group of Leningrad nonconformist artists, which existed from 1974 to 1976. After the ill-fated Bulldozer exhibition in Moscow in 1974, when the authorities sent bulldozers to destroy an outdoor exhibition of paintings, four Leningrad artists who took part in that exhibition (Y. Zharkikh, E. Rukhin, A. Leonov, and I. Siniavin) returned to Leningrad and decided to organize a comparable exhibition of Leningard nonconformist artists. Before the first exhibition of TEV opened at the GAZA Palace of Culture in 1975, a special committee of the Leningrad Branch of the Union of Soviet Artists, headed by the academician Boris Ugarov, previewed the works considered for the exhibition. The strict requirements stated that no work with anti-Soviet, religious, or pornographic imagery would be accepted. Of the 500 invitations produced for the opening, the artists were forced to give to the Ministry of Culture as many as 350. In spite of the fact that the exhibition was open during working hours, from 11 to 5 p.m., it was visited by 8,000 people. By word of mouth, thousands of people

came and stayed in lines for as long as seven hours in order to see art which opposed the dogmas of Socialist Realism.[8]

Rapoport also took part in the second important exhibition of nonconformists which took place at the Nevsky Palace of Culture in September 1975, where as many as ninety artists showed 600 works.

In the 1970s, among Jews in Leningrad willing to be conscious of their identity were many artists. However, Jewish life and religion had to go underground, and as a result all meetings and seminars devoted to the Jewish religion, traditions, history and culture were secretly held in private apartments. The last officially approved exhibition devoted to Jewish culture was *Jews in Tsarist Russia and the USSR*, held at the State Museum of Ethnography in Leningrad in 1939. From that time on, even the depiction of a Torah or typical Jewish characters was considered religious propaganda and was cause for severe punishment. Nevertheless, Rapoport became a founding member of the association of Leningrad Jewish artists known as the ALEF group, which existed from 1974 to 1976.[9] The group took its name from the first letter of the Hebrew alphabet, meaning "beginning." As Rapoport recalled, for participation at the Nevsky Palace of Culture exhibition, he personally searched for and summoned a number of new artists (among them Evgenii Abezgauz and Yurii Kalendarev) who worked on Jewish themes. It was initially at the Nevsky Palace of Culture exhibition hall that future members of the ALEF group found their works exhibited in the same corner. All of the artists carried a symbol of the menorah. They were immediately labeled a "Jewish group" by the other artists and by visitors. The decision to organize a separate exhibit of Jewish artists was born there and then.

Rapoport compiled a manifesto of the group, which indicated that several Jewish artists from Leningrad had united "in an effort to revive the ancient and the Middle-Age Jewish traditions in the arts," stressing that "these traditions were completely forgotten in Russia during the last fifty years, since the departure overseas in 1926 of the Jewish theater Habima." [10] The manifesto read: "We would like to overcome the influence of the Jewish culture of the *shtetl* and to find the sources of the art in the more ancient, deep, spiritual and wise Jewish culture in order to build a bridge from it into the present and the future days."[11] About 4,000 people visited the First Exhibition of Jewish Artists which took place November 21-28, 1975 in a tiny two-bedroom apartment on the Stachek Prospect in Leningrad. Twelve artists exhibited 112 works. Rapoport later admitted that none of the ALEF members were formally observant of the Jewish religious law nor any other religious laws. He recalled: "When ALEF was born in the mid-'70s, we had a very vague notion of what Jewish culture was and, especially, what made up Jewish visual art. One of the youngest, Sasha Manusov, was twenty-eight years old (he died in 1990) – a recent graduate of the Soviet art school, what could he know about Jewish art? The eldest, Osip Sidlin, died when he was sixty-three years old in 1972. He probably knew something about Jewish art, but he took his knowledge with him... But what did we know? We knew about the 'cosmopolitans without kin,' about the execution of Jewish writers, about the great actor S. Mikhoels, who was run down by a truck, about the 'doctors' affair,' about the planned deportation of Jews to Siberia." "Our notion of Jewish art," he continued, " was complex: it was a combination of the Assyro-Babylonian architecture, ruins of Massada, the catacombs of the Villa Torlonia. Through the Russian icon, we managed to see Byzantium, and, through Byzantium, we saw the synagogue frescoes of Dura-Europos and Beth Alpha. With our naïveté, we attributed to Jewish culture the best achievements of world culture known to us."[12]

The ALEF group was not based on a similarity of styles or even themes, but "on a shared concerns for threatened values." Rapoport insisted on including in the group several leading Leningrad artists who were not of Jewish ethnic descent. This wise decision significantly improved the artistic quality of the group.

The work of the group was extremely diverse stylistically and thematically, varying from explicit references to Russian icon painting and biblical themes to political commentary. For the first Jewish exhibition in 1975 Rapoport chose a painting, *Jesus Christ and a Samaritan Woman*, which adhered to the idea of the chosen people of Israel. As he noted, he felt it appropriate to show this subject to the many non-Jewish visitors of the exhibition as a symbol of the unity of the Judeo-Christian culture.

In December of the same year, a similar exhibition, but one with more artists-participants,[13] was shown in Moscow, where as many as 5,000 people visited it. From June 3 to 12, the second exhibition of sixteen Jewish artists, who had already been organized in the ALEF group, took place at Abezgauz's apartment in Leningrad. The Soviet authorities attempted to convince Abezgauz's neighbors to complain that the people visiting the exhibition created a lot of noise and ruined the communal order, so that they would be able to close the show. In addition, to make it more difficult for the artists to communicate, the authorities turned off the telephone at the apartment, and sent militiamen to watch the artists day and night.

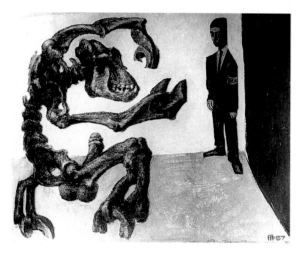

**Sex - Cadaver (The Corner)**
Oil on canvas, 1967
39 3/8 x 31 1/2 in; 100 x 80 cm.
Whereabouts unknown

In the years following 1975, a photodocumentary exhibition of the works in these shows was shown in many cities in the United States, circulated by the Bay Area Council for Soviet Jewry, under the direction of Regina Waldman, who had received smuggled transparencies of the images from the ALEF group's show. Since that time most of the group's members have emigrated to the West.

In 1989, the ALEF group was again reunited in Louisville, Kentucky, when curator Jan Arnow and Project Director Laurel Garron, organized an exhibition *Creativity Under Duress: from Gulag to Glasnost*, where recent works of eleven former members of the group were presented to the American public. [14]

As Rapoport once stated: "To be an artist in Russia has always been an honorable and respected position, to be a nonconformist artist has been a very extreme position, to be a nonconformist Jewish artist has been a very sensitive, almost scandalous situation."[15] For their participation in "dissident" ALEF exhibitions, five artists-participants were fired from their jobs, accused of dissident activities. Rapoport was one of them. He was proclaimed a "Zionist-Fascist" and a "militant Christian artist," and was expelled from the Soviet Union in 1976.

Konstantin Kuzminsky, a talented nonconformist poet and one of the leaders of the Leningrad nonconformist movement, who was also a faithful friend of Rapoport, writing on the artist in his Anthology of Modern Russian Poetry, commented on Rapoport's 'jewishness': "Jewish? Russian?- In Russia he was a Jew. In Russia to be a Jew was unadvantageous, and that is precisely why he chose to be one. Here [in the USA], when he was suggested to continue exploring Jewish themes — which is advantageous — Rapoport exhibits *Crucifixions* and creates fairytale illustrations based on Russian *lubki* ... Since this is unadvantageous... ."[16] Without a doubt, during his entire life, Alek Rapoport remained a true nonconformist, an artist who refused to compromise.

# NOTES

1    Marina Tsvetaeva, *A Poem of the End*, 1924, Collection of Verses, Poems, and
     Drama Pieces, in 3 volumes, volume 2, Moscow: PTO Tsentr, 1992, p. 463.

2    Alek Rapoport, *ALEF Group*, unpublished manuscript, San Francisco, CA, 1991, p. 1.

3    All information about Rapoport's early years is based on Irina Rapoport's unpublished
     memoirs.

4    Alek Rapoport, *ALEF Group as an Offspring of the Russian Judeo- Christian Tradition*,
     unpublished manuscript, San Francisco, CA, 1991, pp. 1-2.

5    pro-Jewish.

6    pro-Christian.

7    from the word *barracks.*

8    An important information on exhibitions of Leningrad nonconformist artists can be found
     in Irina Rapoport, *About the Nonconformist Movement in Leningrad*, unpublished
     manuscript, San Francisco, CA, 1977. On these exhibitions see also: Yurii Novikov,
     *Chetyre Dnia v Dekabre*, Iskusstvo Leningrada 1 (1990): pp. 97-102; Aleksandr Borovsky,
     *Neformaly: Mezhdu Proshlym i Budushchim*, Iskusstvo Leningrada 3 (1989): 39-47.

9    Among the participants of the first ALEF group exhibition were Evgenii Abezgauz (born
     1939), Anatolii Basin (born 1936), Leonid Bolmat (born 1931), Aleksandr Gurevich
     (born 1944), Yurii Kalendarev (born 1947), Tatiana Kornfeld (born 1950), Aleksandr
     Manusov (1947-1990), Aleksandr Okun' (born 1949), Sima Ostrovsky (1938-1995),
     Alek Rapoport (1933-1997), Olga Shmuilovich (born 1948) and Osip Sidlin (1909-1972).

10   The ALEF group Manifesto was written by Alek Rapoport in 1975; published in
     E. Sotnikova, *The Leningrad Exhibition of Jewish Artists*, Samizdat, 1976. Translated from
     Russian.

11   Ibid., p. 9.

12   Alek Rapoport, *ALEF Group as an Offspring of the Russian Judeo-Christian Tradition*, p. 3.

13   The participants of the second exhibition of Jewish artists were E. Abezgauz, A. Arefiev,
     A. Gurevich, Y. Kalendarev, T. Kornfeld, A. Manusov, A. Okun', S. Ostrovsky,
     B. Rabinovich, A. Rapoport, G. Shapiro, O. Shmuilovich, Sh. Shwarts, O. Sidlin
     (posthumously), R. Vasmi, and V. Viderman.

14   See *Creativity Under Duress: From Gulag to Glasnost*, exhibition catalogue, Louisville,
     Kentucky: Louisville Southeastern Paper/Hamilton Printing, August 1989.

15   Alek Rapoport, *Birth of the ALEF Group*, unpublished manuscript, San Francisco, 1991,
     p. 5.

16   Konstantin K. Kuzminsky and Gregory L. Kovalev, *The Blue Lagoon Anthology of Modern
     Russian Poetry*, Volume 5B, Newtonville, MA: Oriental Research Partners, 1986, p. 150.

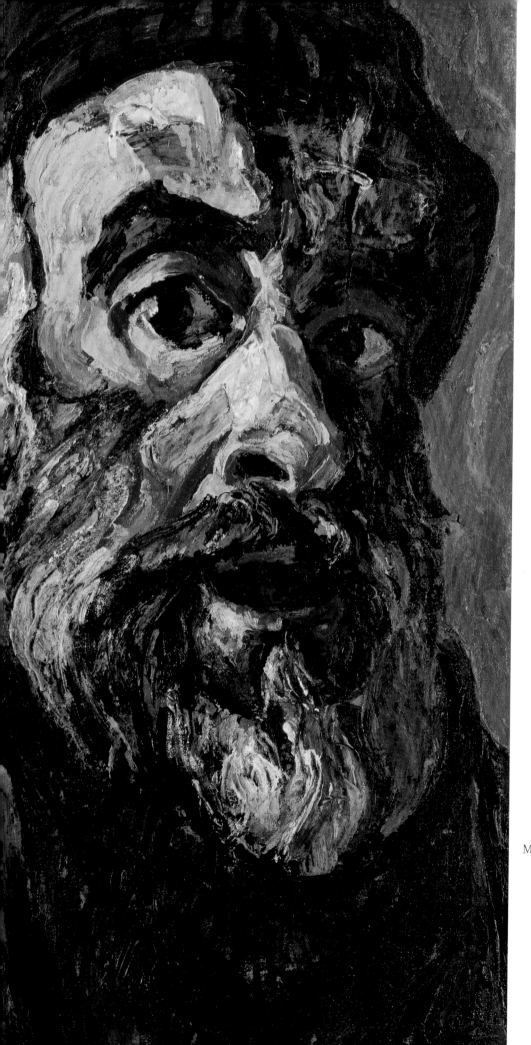

**Self-portrait**
Mixed pigments on burlap, 1990
48 x 24 in; 122 x 61 cm
Collection I. & V. Rapoport,
San Francisco, CA

# ALEK RAPOPORT:
# AN ARTIST OF THE TRAGIC MUSE

John E. Bowlt

Aleksander Vladimirovich Rapoport was an artist of the tragic muse. For him the artistic process was a constant endeavor to reconcile the fundamental contradiction confronting every artist, i.e., how to record in tangible form (a painting, a poem) the intangible vision; how to describe the Truth in the relative terms of truth. Rapoport's constant concern with this dilemma manifested itself not only in his frequent emphasis on individual freedom within the collective environment or in his fusion of linear and inverted perspectives, but also in his ecumenical plurality (a son of Israel who embraced Christianity) and his very way of life (ever unready to accept ideological compromise, whether Communist or Capitalist).

A Russian artist living in America, a craftsman for whom manual dexterity and private inspiration were infinitely superior to technological gloss, Rapoport was an inhabitant of the Far West who hankered after the Near East, an acute observer of social reality who painted and wrote in eschatological terms and who tried constantly to accommodate our profane rituals within his liturgical space. He wrote in 1983: "Via Byzantium, Tintoretto and Cézanne, right down to us, Russian artists, everything derived from the Mediterranean, everything was concocted in that cauldron. It was the cradle wherein our temples, our cities, our rhythms, our art were born."[1] The contrasts are many, although, ultimately, for Rapoport the contemplation of these opposites and the search for an artistic resolution transcended the differences.

Indeed, the fact that Rapoport gave his energies to this quest, especially during his final years, and that death overtook him while he was working in his studio is symptomatic of his total dedication to the creative process. As he used to assert, "My work is a means of meditation"[2] and, obviously, it was inward contemplation rather than outward construction that afforded him the greatest peace of mind. In this respect, it is vitally important to remember that Rapoport, an explorer of many media and styles, was a single artistic personality. He may have experimented with painting, drawing, lithography, poetry, philosophical discourse and epistemology, but these were only fragments of an entire mosaic. In other words, if we are to appreciate Rapoport's authentic physiognomy, we must observe all his endeavors in unison — even if he was always haunted by the ultimate inadequacy of matter (the pictorial image) to non-matter (the spirit).

As both the incubator and the victim of fierce oppositions, Rapoport experienced profound psychological tension. He was traversing a desert of misunderstanding and he uttered unheeded warnings of the dangers of hedonism, while appealing to the Ancient World for inspiration and renewal. Rapoport's declarations were all the more sobering when we think of the complacency and social indifference in which he lived. Forced to exercise a creative will that he both vaunted and feared, he maintained an uneasy position within the Western reception of Russian art in general. Particularly in the US, the Russian avant-garde tends to be recognized for its achievements in geometric abstraction, epitomized by Kazimir Malevich's *Black Square* (1915, Tretiakov Gallery, Moscow). The sighs of gratification that accompany our contemplation of the cool forms of El Lissitzky, Liubov Popova and Alexander Rodchenko reinforce this impression, and it is their esthetic that has defined the Western perception of modern Russian art. True, the lyrical abstraction of Vasilii Kandinsky or the anecdotal narratives of Marc Chagall are also popular, but, by and large, these painters were outside the Russian avant-garde both physically and esthetically.

Be that as it may, if we choose to re-examine the history of modern Russian culture, we find that it accommodates an alternative tradition, an "Expressionism" that paralleled the development of Suprematism and Constructivism, and one that has a much larger following in Russia, but

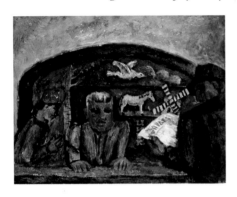

**The Shooting Gallery**
Tempera on masonite, 1967, 20 x 26 in; 50 x 66 cm.
Coll. N. & M. Dunev, Sausalito, CA

Lamentation Near the Temple Wall
Relief, tempera on masonite, 1976, 18 x 27 in; 46 x 69 cm.
Coll. S. & J.P. Garlington, St. Simon's Is., GA

little resonance in the West. While it would be banal to associate this alternative convention too closely with the dual tradition that distinguishes post-Petrine Russia (Slavophiles vs. Westernizers, the ecclesiastical vs. the secular, the communal vs. the existential), it nevertheless leaves a strong imprint on 20th century Russian art (we think of Vasilii Chekrygin, Pavel Filonov, Solomon Nikritin, and Mikhail Vrubel). Rapoport's primary teachers, Nikolai Akimov and Evgenii Sagaidachny, also belonged to this alternative tradition; the former was a pupil of Savelii Zeidenberg (one of Chagall's early teachers), and the latter was a colleague of Filonov within the Expressionist faction of the Union of Youth society. Rapoport, too, was drawn more towards this tendency than towards Constructivism and, like the paintings of his spiritual forebears, his esthetic distortions seem to extend both an extreme emotional charge and a vital and visceral force — in the same way that the art of his European heroes, Tintoretto, El Greco, Rembrandt and Rouault does.[3]

· Like Filonov, like the German Expressionists such as Ernst Ludwig Kirchner or Ludwig Meidner, Rapoport often produces a *Nahbild* that pushes a key component of his vision up to the surface of the painting (such as the padded shoulders in *Tourists in San Francisco* (p. 85), forcing us to engage. All tell us that our world cannot be reduced to reasonable order, that emotional state is superior to political or geographical state, and that no single geometry, Suprematist or otherwise, can accommodate the pulsating disorder beneath the surface of things.

But the primordial chaos and shapelessness of this nether world appeals little to Western logic, to which a Cubist painting, an architectural drawing or a minimal construction, with their ostensible reason, are more acceptable. That is why, recognizing the formal equilibrium, but doubting the inner ardency, Rapoport referred to Picasso as a "charlatan of genius."[4]

To some extent, then, the Expressionist tendency can be identified with St. Petersburg/Leningrad rather than with Moscow, an association explained perhaps by the unnatural condition of the city (built on a marsh) and its meteorological instability — which seem to have contributed directly to the theme of ambivalence and schizophrenia in Russian literature and art (N. Gogol's *The Nose*, F. Dostoevsky's *The Double*, A. Blok's poem *The Stranger*). Some of the most "Expressionist" members of the Russian new wave lived and worked in Leningrad such as Sergei Gollerbakh, Evgenii Rukhin, and Yakov Vinkovetsky, while Yurii Dyshlenko, Mikhail Kulakov, and Oleg Tselkov were colleagues of Rapoport studying under Akimov at the Leningrad Theater Institute in the late 1950s and early 1960s. All these artists are now remembered for their highly charged emotional landscapes and their juxtaposition of cosmic energy with the existential self. Perhaps Rapoport had this in mind when he wrote that "Whatever the artist does, his work must bear the divine prototype, for God sees Himself in things and creations outside of space, outside of age and history, and in an extra-temporal light."[5]

Given this "Expressionist" emphasis, how should we read Rapoport's visual commentaries? Once again, in order to answer this question we must take account of the totality of Rapoport's system and try to recognize his inherent complex of cross-references. For example, while the physical dislocation and imbalance of paintings such as *Tourists in San Francisco* or *24 Hours* (p. 87) are disorientating and perplex, consultation of other fragments of Rapoport's aesthetic and philosophical universe provides tentative explanations. In brief, a perverse series of parallels and intersections can be established between Rapoport's evocations of the lower depths of San Francisco and the celestial plane of deities and saints. In composition and color, for example, the *Three Men on Market Street* (p. 79), finds a reincarnation in the *Three Men in the Plains of Mamré* (p. 67), which can be accepted as the mirror image of the *Trinity in Dark Tones* (p. 63), which in turn, pays homage to Rublev's *Trinity*. Rapoport's eulogy of motherhood in *Mission Street Family* (p. 91) or *Red Skirt* (p. 95) also extends the artist's praise of the Virgin Mary implied in the works such as *Dormition of the Virgin* (p. 63)

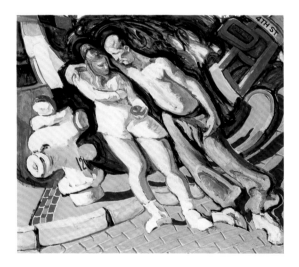

and *Annunciation* (p. 65). Perhaps the clearest example of this transcension is his insertion of the Biblical allegory into the immediate ambiance of downtown in *South of Market, Adam and Eve*.

How did Rapoport resolve the fundamental divisions that he saw around him? On one, immediate level, he remained a dissident, commenting on social injustice and political nonchalance and using his paintings and reliefs as ideological manifestoes. A nonconformist in the

**South of Market, Adam and Eve**
Mixed media on linen, 1994
48 x 54 in; 122 x 137 cm.
Coll. V. Alexanyan & M. Migdal, Palo Alto, CA

Soviet Union, Rapoport also seemed to identify himself with individuals and movements that are often regarded as peripheral and transient to the American mainstream. At the same time, it would be unwise to recognize only the external disharmonies of Rapoport's art, for, ultimately, and again like Filonov and Vrubel, Rapoport was the seer of principles and structures that transcend mere human foible and social mismanagement. Undoubtedly, it is the double meaning and ulterior attachment that distinguish Rapoport's descriptions of the inner city from the more didactic expositions of predecessors such as Louis Lozowick and Phillip Evergood. Formally and structurally, Rapoport seems to be paying homage to the cause of American Social Realism, yet he never loses sight of the grace above the wear and tear of urban squalor, a vision that nurtured his many parallel religious paintings of the 1980s-90s. Rapoport yearned for the wholeness of Christendom and accepted the art of the Renaissance as a primary expression of spiritual serenity. Mistaken or not, Rapoport also singled out the eras of Ancient Greece and Byzantium, identifying them as the zenith of artistic civility, and he looked back to this legacy with nostalgia, contrasting it to what he identified as the spiritual degradation of contemporary Western culture — and offering it paradoxically as the only legitimate future for our ailing world.

**Simeon Stylites Rescues the Ship** (Byzantine legend)
Gouache on goznak paper, 1973
6 3/4 x 6 3/4 in; 17 x 17 cm.
Coll. N. & C. Gruen, El Cerrito, CA

**Death of Simeon Stylites** (Byzantine legend)
Gouache on goznak paper, 1973-74
6 1/2 x 6 1/2 in; 16 x 16 cm.
Private collection

We may or may not agree with Rapoport's abrupt censure of the status quo, of the advance of the machine, and of the substitution of "divine" information with computerized data. But, like a prophet, Rapoport reminded us of the surrounding hazards, while illuminating our path forwards. In this respect, Rapoport's role as logician or orator is not subservient to his role as visual artist, for, as he asserted on many occasions, contemporary Western civilization lacked "Word, Man, Spirit,"[6] whereas his own creativity was born from the Word.[7] True, few heeded his Word, a disaffection that may be to his advantage inasmuch as Rapoport, far from being out of touch, was speaking from a distant zone to a bewildered public: he was a prophet in the wilderness. As Vasilii Kandinsky said almost a century before, "the artist is a tsar...not only because his power is grand, but also because his obligations are mighty...[he is] a priest of the beautiful."[8]

Perhaps because of Rapoport's skepticism of everyday Western reality, his art is tinged by a sense for the apocalyptic. To Rapoport, contemporary culture, after having eliminated man and humanist ideals, was now guided mechanically and automatically by the autocracy of

commercial success. Rapoport argued that such a path could lead only to a diabolical corruption in which the world of appearances would replace the loftier world and where the music of the spheres would become inaudible beneath the clamor of technology. He declared: "From the moment art ceased to be part of religion and began to serve the worlds of the materialistic consumer and party ideology, it became a record of its own destruction."[9] Once again Rapoport's ecumenical paintings demonstrate that our only future is our past and that the salvation from our satanic mills will come only through a return to the consonance of Mediterranean, especially Byzantine, civilization.

It is important to remember however, that Rapoport argued vehemently against any outward restoration of the past, for he realized that the physical repair and management of a work of art, Byzantine or otherwise, was generally a futile task. Restorers are victims of the ephemeral prejudices of their own societies and impose these upon the subjects of their investigations. Rapoport's long deliberation on what he saw as the false restoration of the Sistine Chapel summarizes his extreme suspicion of the physical restoration of cultural symbols: "The material aging of a work [of art] is natural. Any attempt to 'rejuvenate' it by applying the 'media of contemporary science' ends miserably just as any attempt at rejuvenating old people by applying the same 'media of contemporary science' does."[10] On the other hand, Rapoport seemed to think that if genuine restoration of an antiquity was impossible or at least hazardous, then the building of new vessels to bear the spirit of antiquity was feasible and desirable. After all, in his own religious works such as *The Lord* (p. 45) and *From the Life of St. Nicholas* (p. 57), Rapoport was trying to recapture the Byzantine spirit, while maintaining the basic formal principles of the iconic heritage.

In pictorial structure, too, Rapoport combined the demonic and the divine as if to emphasize that, even if morally antagonistic, the two spaces are guided by the same universal principles of evil vs. good and the temporal vs. the infinite, and that both are part of human destiny. For example, Rapoport played with spatial renderings, often resorting to an inverted or central perspective or to a non-Euclidian space that makes flat surfaces undulate and corners curve, such as the elliptical, "Baroque" vortices of the *Images of San Francisco No. 10 Chinatown* (p. 105) and the *Three Deeds of Moses* (p. 59). The exaggerated stride of the first of the *Three Men on Market Street* (p. 79) or of the *Latinos on Mission Street* (p. 93) complements that of the *Doubting Thomas* (p. 39) stepping away abruptly from us to Him in *The Incredulity of St. Thomas* (p. 61). Indeed, many of Rapoport's pictures are concerned with a rite of passage (and every street represents that) — as in *Crossing* (p. 83) with its maelstrom of races, social stations, dresscodes, ages and sexes, or in the men suspended in limbo in *Images of Mission Street No. 12* (p. 105). The special role of light in Rapoport's paintings assumes complex meaning when we recall that light for him was the metaphor of enlightenment and of the divine presence. So it is not fortuitous that the luminous paints in *Images of Mission Street No. 7* (1989) and *Girlfriends* (p. 97) should elicit the hieratic colors of icons, since Rapoport's experiments with the spatial arrangement of figures and their illumination were more than mere games, and his writings show an extensive knowledge of perspective theory and purpose. His ample references to Pavel Florensky, specifically to the discussion of inverted perspective, help us to understand basic concepts of pictorial space as a metaphor for direction. As a result, Rapoport often replaced an object's proximity or distance by its semantic importance, emphasizing a physical form, which according to the academic style, had no right to be bigger. For Rapoport, hierarchical or symbolic importance transcended spatial position, as illustrated in *South of Market Warehouses* (p. 99) and *Images of San Francisco No. 10 Chinatown* (p. 105).

Ultimately, Rapoport believed in the "universal laws of Harmony,"[11] suggesting that the disgrace of poverty or the ugliness of racial inequality were fleeting elements, the flipside

of an ulterior consonance, a mere time warp in the divine permanence. Certainly, the constant mismatch of Truth and truth was a primary stimulus to Rapoport's artistic exploration. Here was a voyage of discovering rather than of discovery, of process not result, a condition that, in general, can be identified as a salient characteristic of 19th and 20th century Russian art. Such was the approach of Alexander Ivanov, Russia's religious painter of the 19th century, who spent twenty years painting his masterpiece *The Appearance of Christ to the People* (1837-57), only to be ridiculed by Tsar, Academy and public. Vrubel, Russia's primary artist of the *fin de siécle*, also strove desperately to impose his diabolical visions onto the seismic planes of his paintings. The St. Petersburg avant-gardist, Filonov, one of Rapoport's spiritual mentors, even maintained that his paintings grew as botanical organisms, components of a universal flowering. "My principle," Filonov declared in 1923, "presupposes the sphere as being not just space, but a biodynamic one in which the object resides in constant emanations and cross-insertions."[12] Rapoport, too, used the botanical metaphor to emphasize the procedural energy of his art, proposing that "my work on a particular theme resembles a living plant."[13]

Rapoport wished to tell us of voices heard and visions seen: and it was sometimes a desperate desire as we sense in his *Self-portrait as a Mask of Mordecai* (p. 10). There is sadness, of course, in the fact that few understood his message, although, as often happens in the world of creativity, the passing of the artist has turned his art into a historical testimony and a chronological document. Fortunately, the resultant distance elicits within us a new detachment and a much deeper appreciation.

## NOTES

[1]  A. Rapoport, *Statement* (1983), p. 2, typescript. Artist's estate, San Francisco.
[2]  I. Rapoport, *Alek Rapoport: Biography* (1997), p. 33, typescript, Artist's estate, San Francisco.
[3]  A. Rapoport, *Traditsiia i Novatorstvo v Izobrazitelnom Iskusstve*, 1994, p. 11, Artist's estate, San Francisco.
[4]  Ibid., p. 8.
[5]  Ibid., p. 1.
[6]  Ibid., p. 8.
[7]  A. Rapoport, *Statement* (1997), p. 10, typescript. Artist's estate, San Francisco.
[8]  N. Kandinsky, intr., Vasilii Kandinsky: O Dukhovnom v Iskusstve, New York, Rausen, 1967, p. 144.
[9]  A. Rapoport, *Statement* (1980), p. 1, typescript. Artist's estate, San Francisco.
[10]  A. Rapoport, *Traditsiia i Novatorstvo v Izobrazitelnom Iskusstve*, p. 7, Artist's estate, San Francisco.
[11]  A. Rapoport, *Statement* (1981), p. 3.
[12]  P. Filonov, *Deklaratsiia `Mirovogo rastsveta'* in *Zhizn iskusstva*, Petrograd, 1923, No. 20, p. 15.
[13]  A. Rapoport, *Statement* (1986-96), p. 8, typescript. Artist's estate, San Francisco.

*T*en years of emigration on this peninsula named San Francisco have made me re-think and re-evaluate many things. Emigration, exile and prison are given to man for self-improvement.

*And now I look back (or is it forward?): Byzantium, the Middle Ages, the Renaissance. That is were my teachers are; unfortunately I have sometimes been unfaithful to them.*

*Now I am once more asking for their help. I do not want trickery; I want real art of conscience.*

A. Rapoport, 1985

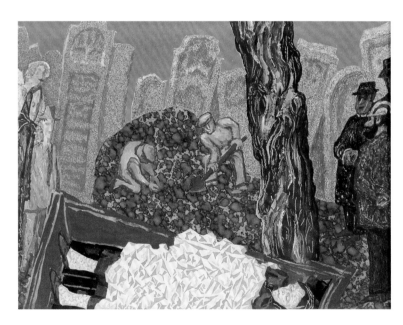

**Burial at Chernovtsy**
Gouache on goznak paper, 1974
7 1/2 x 10 in; 19 x 25.4 cm.
Coll. B. & R. Freeman, Lakewood, OH

# CHRONOLOGY

## 1933-1941

Alek Rapoport is born on November 24, 1933 in Kharkov (Ukraine). Spends his childhood in Kiev and is four years old when both of his parents are arrested during Stalin's "purges." His father is shot in 1939 and his mother spends ten years in a Siberian labor camp. A. R.'s letters to his mother are filled with drawings. His aunt, with whom he lives, is terrified when she received a letter from the postal censor beginning "Do not allow your boy to draw portraits of our leaders, he destroys them." This is A. R.'s first clash with authorities.

## 1941-1945

At the beginning of the Great Patriotic War (World War II), A.R. is evacuated to the city of Ufa (Ural Mountains) on the day before the German occupation of Kiev. While these are times of extreme loneliness, cold, hunger, and deprivation, they also mark the beginning of his serious drawing studies. He begins by copying drawings found in random editions of the popular Soviet magazine "Ogoniok" ("The Light") and old editions of "Niva," which contain reproductions of sentimental German paintings and pre-Rafaelites. The local art museum leaves a profound impression on A.R.

## 1945-1950

At the end of the war, A.R. is living in Chernovtsy, in the Western Ukraine. At the House of Folk Arts, he finds his first art teacher, E. Sagaidachny, a former member of the non-conformist artist groups "Youth Union" and "The Donkey Tail," popular during the 1910s -1920s. A. R. is very impressed by Sagaidachny's unusually bright watercolors, who agrees to teach young Alek watercolor technique. His main studies consist mostly of painting still-lifes and landscapes of old Russian and Jewish cemeteries.

During these years he also studies with Bekhlemicheva, an exiled artist and relative of the once famous academic sculptor. Impressed by A. R.'s talent, she later facilitates his move to Leningrad where he will enrol into the Art College. Because reproductions of visual art are scarce at this time in the provinces, A.R.'s main source for information concerning art is a collection of postcards of European paintings belonging to the Ukrainian intellectual Rudensky, and old editions of *Large Soviet Encyclopedia*, which were later censored and taken out of libraries.

## 1950-1954

Moves to Leningrad in 1950 and enters the famous V. Serov School of Art. His association with the school will last eight years, first as a student, and then, from 1965 to 1968, as a teacher.

Since only the official style of "social realism" reigns during this time, most of the faculty of the Art School have to conceal any prior involvement in non-conformist art movements. (Ya. K. Shablovsky, V.M. Sudakov, A. A. Gromov introduce their students to Constructivism only through clandestine means.) The school stresses the study of fundamental drawing skills (A. A. Gromov) and an appreciation for Italian Renaissance art (G. A. Glagoleva).

During these years A.R. continues to educate himself, spending hours in the Hermitage museum, copying paintings of the Old Masters, and studying at art and public libraries. Such books as *Rembrandt's Etchings* by L. Feinberg, and *Delacroix's Palette*, by R. Pio are his favorite books written for artists. Although deeply influenced by Rembrandt, A. R. begins to identify himself with Leningrad's analytical school of painters, which include A. Ivanov, M. Vrubel, K. Petrov-Vodkin, and P. Filonov.

*"My development as a painter was a slow process,"* A.R. recalled. *"Neither the long and dark winters of Leningrad, nor the oppressive years of the 1950's contributed much to my sense of color. That sense of color came much later, after visiting the exhibitions of Cézanne, Rouault, and Konchalovsky. Copying Cézanne's works contributed most to it. I copied works by Cézanne with great care; it gave me the understanding of color structure combined with an analytical drawing system. The result was impressive; it was the best way for me to study art."*

### 1954-1957

His last year in college is interrupted by the military draft. He is stationed in Birobizhan (a Jewish Autonomous Republic) and in the city of Khabarovsk. During his free time he paints and draws, making a series of sketches vividly depicting scenes of a soldier's everyday life, and portraits of friends. His only oil painting , *The Taking of a Hill* becomes a ceremonial gift to the local art museum, where it hangs on permanent display.

**Self-portrait**
Ink on paper, 1962
Dimensions and whereabouts uknown

### 1958

At the conclusion of his military service, A.R. returns to Leningrad and graduates from the Serov School of Art with a BA. His graduation work, *Laying the Wreaths on the Field of Mars* (1958), is declaimed as "formalist," a stigma which follows him from then on.

A. R.'s generation, Leningrad's *Boys of the 50's* breathe a little air of freedom, and rejecting the omnipresent and officially sanctioned "social realism," express increasing interest in contemporary art. Expositions of French Impressionists arrive to Leningrad, followed by other exhibitions of Modern Art from different European countries. This new freedom contributes to and generates a great new source for ideas. In 1958 A.R. acquires a distinctive style, as represented in two works, *Geometrical Self-portrait*, and *Cancer Patient*.

### 1959-1963

Studies stage design in Leningrad's Institute for Theater, Music, and Cinema under the supervision of N.P. Akimov. Akimov's students are chosen from among the most talented and from those expelled from other schools for "leftist views," (Soviet euphemism for anything outside the official taste). He teaches Russian Suprematism and Constructivism while encouraging his graduate students to apply their knowledge to every field of art design. This relaxed and friendly atmosphere will be remembered as one of the brightest times in A. R.'s life. Akimov's personal style will later contribute to A. R.'s own teaching methods in Technical Aesthetics and Design.

A. R. considers himself a practicioner of Russian Constructivism with roots in ancient Mediterranean and Byzantine art forms. Is strongly influenced by Tartu's school of Structuralists and Iu. Lotman, the creator of the semiotic system. Engages in deep study of Byzantine Art and icons. Father Pavel Florensky, a Russian

Orthodox priest, and L. Zhegin, the art historian, were his last teachers in Russia.

*"I can not speak nor not speak the name, but I have to speak the name of my only Supreme Teacher, whose teaching has no shadows but only the magnificent light, which reflects on every piece of Christian Art and its masters,"* wrote A. R. in 1979.

In 1961 marries Irina Vasilyeva.

In 1963 receives his MFA with the stage and costume design for the martyred Jewish playwright Isaac Babel's *The Sunset*. His work is highly acclaimed. In preparation, he travels to the southwest regions of the Soviet Union, immersing himself in the study of Judaism and its legacy while collecting objects of Judaic iconography from former ghettos and disappearing synagogues.

### 1963-1970

Intensive period of theatrical design work including sets and costumes for *Good Woman from Szechuan*, and *Furcht und Elend des III Reiches*, by B. Brecht, *The Queen of Spades*, by A. Pushkin, *Charley's Aunt*, by Th. Brandon, *The Armor Train No. 14-69*, by V. Ivanov, and many others. Stage design work is exhibited at Leningrad's branch of the Union of Soviet Artists, and is used in theaters in Leningrad and Volkhov.

In 1964 son Vladimir is born.

Works as an artist's assistant at Lenfilm studios (*Workmen's Settlement*) and as a book designer and illustrator for the publishing houses: Aurora, Detgiz, etc.

In 1965 teaches composition, design, and human anatomy at the V. Serov Art School in Leningrad organizing a new liberal course in *Technical Aesthetics*, introducing his students to Lotman's theory of semiotics, Russian Constructivism and contemporary Western Art. As a result of his "radicalism," he is fired for "ideological conspiracy."

Devotes his energy to his own creative work, centering around biblical

**Furcht und Elend des III Reiches (I)**
Stage design for B. Brecht's play,
Gouache, collage, photomontage, 1962
24 x 32 in; 60.9 x 81.3 cm.
Coll. Museum of the Institute of Theater Arts, St. Petersburg

**Furcht und Elend des III Reiches (II)**
Stage design for B. Brecht's play,
Gouache, collage, photomontage, 1962
24 x 32 in; 60.9 x 81.3 cm.
Coll. Museum of the Institute of Theater Arts, St. Petersburg

**Furcht und Elend des III Reiches (III)**
Stage design for B. Brecht's play,
Gouache, collage, photomontage, 1962
24 x 32 in; 60.9 x 81.3 cm.
Coll. Museum of the Institute of Theater Arts, St. Petersburg

themes, anti-Semitism, and subjects of everyday life. Cultivates himself as Jewish artist. (The Israeli victory in the Six Days War raises interest in Jewish culture and its biblical past among Jewish and gentile intellectuals.) The most important works of that period, *Three Figures* (1966), *Corner* (1967), are serial images of talmudic scholars.

Spends summers in Pavlovsk.

### 1970-1976

Joins non-conformist art movements to preserve the traditions of Russian iconography and the style of Constructivism/Suprematism of the 1910's.

*"I considered the (non-conformist artists) movement to be very important for Soviet Art. It was not only a fight for independence and democratization of the art itself, but also the fight against the oppression and totalitarianism of Soviet authorities. The art of those 'neglected' artists in itself was a starting point of social criticism. This was real non-conformism in art, and it did not appear out of the blue. Its sparks were always smoldering, making its way from underground. The first non-conformist artists were Filonov, Tatlin, Falk, Larionov, and Goncharova. Then came our generation. The Soviet authorities always tried to suppress and extinguish our creative works, to diminish its importance or to ignore its very existence. But, despite this, the art became recognized and accepted."*

Despite persecutions by the authorities of non-conforming artists, including arrests, forced evictions, and assassinations, their exhibitions are tremendously successful.

In 1974, the exhibition of fifty artists at the GAZA Leningrad Palace of Culture was visited by 8,000 people in 4 days. The 10-day exhibition of 100 artists at Leningrad's Nevsky Palace of Culture in 1975 is visited by 40,000 people, despite the KGB's strict limitations. The 1976 apartment exhibitions in Moscow, are attended by 100,000 people.

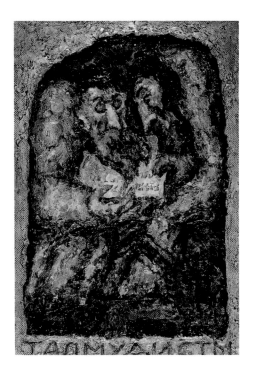

**Talmudic Scholars**
Relief, oil on masonite, 1963
16 1/2 x 11 1/2 in; 42 x 29 cm.
Whereabouts unknown

Becomes an active member of the non-conformist artists group TEV- Fellowship of the Experimental Exhibition.

In 1974 co-founds the anti-establishment group ALEF (Union of Leningrad's Jewish Artists), exhibiting in Leningrad and Moscow. Increased tension with the authorities brings the scrutiny of the KGB including "friendly conversations," surveillance, detentions, and house arrests, becoming increasingly dangerous to remain and work in the USSR. In October 1976, A. R. and his family are forced to leave Russia.

### 1976-1977

Travels to Austria and Italy. Exhibits at the Venice Biennale, *La Nuova Arte Sovietica-Una prospettiva non ufficiale* (1977), and participates in television programs about non-conformist art in the Soviet Union. Creates his first lithographic

work at Edizione e Stampe d'Arte, with *Lad at the Fair*, which continued his theme of Jewish characters from Babel's play *Sunset*.

In 1977 granted immigration status to the U.S. and settles in San Francisco.

## 1977-1987

Between 1977 - 1985 works as a draftsman-designer of stage equipment at S.L. Auerbach & Associates Inc. Continues to paint, but experiences difficulty fitting into the American contemporary art mainstream which he considers frivolous, career-oriented, and devoid of any spirituality or artistic merit.

*"The abundance of technical innovations and lack of any substance, characterized the American lifestyle, reflecting in its art,"* said A.R. *"Americans realized at some moment (somewhere in between T. Benton and J. Pollock) that the lack of tradition and continuity will never give them precedence in art. They substituted visual art with visual gimmicks, and not without reason. The Japanese-American sculptor, Noguchi, ironically noticed that the ideal American artist is the inventor, such as Alexander Graham Bell."*

Begins work on series *Images of San Francisco*. These images will become one of the two major subjects in his paintings for the rest of his life.

In 1981 has first personal exhibition in San Francisco at the Nanny Goat Hill Gallery, and publishes with Scythian Books (Oakland, California), illustrations for *Erotic Tales of Old Russia*, by A. Afanas'ev.

With the assistance of Sister Ann Gillen, SM, from the Society of the Holy Child in Chicago, donates four works On the Theme of St. John's Gospel to His Holiness Pope John Paul II.

In 1983 exhibits religious paintings at Mercy Center in Burlingame, Califorina and donates *St. Francis of Assisi* to the Center. Protesting the refusal by American art institutions to exhibit his religious paintings, he embarks on a hunger strike and publishes the following manifesto:

*"I am declaring a war against spiritlessness, anti-religious context, and the commercialization of contemporary art. I pronounce this two week hunger strike in support of religious art.*

*1. In the Soviet Union religion is banned in order to dominate the masses under the single idea of communism. In the United States, religion is practically drawn out of people's lives because the society succumbs to the idea of commercialization.*

*2. In the Soviet Union, the ideology of the communist party dominated the ideas of spirituality. In the United States, the ideas of the market dominate the human spirit.*

*3. In the Soviet Union, the communist ideology dominates art. In the United States there are no ideas in art.*

*4. In the Soviet Union, the presence of communist ideology is most important. In the United States the frame and painting medium are more important than the painting itself.*

*5. In the Soviet Union, where I was the religious dissident artist, religious art was crushed by bulldozers. In the United States, where I am still a dissident, religious art is crushed by the public's indifference.*

*6. In the Soviet Union, the killing of religious art and religion itself brought the country on the brink of disaster. In the United States the ignorance to the value of spirituality might cause the same effect."*

In 1984 meets Michael Dunev who becomes his friend and representative, thereafter organizing all of A. R.'s exhibitions.

1985 creates his seminal work, *Self-portrait as a Mask of Mordecai*.

A visit to Spain leaves a profound impression on him and confirms a personal connection to its art and culture. He begins a series of paintings inspired by his experiences in Spain.

### 1987-1993

By 1987 devotes himself completely to his creative work, isolating himself almost entirely from the artistic community in order to concentrate on his ideas and purge any external influences from his creative process. His work increases its emotional impact as his technical skills become fully developed. This change boosts productivity and gives him increased energy.

*"After ten years of fighting with emptiness and unsatisfactory attempts to change American views in art, it seems that now I can take things the way they are and draw strengths from within myself."*

Participates in numerous exhibitions in San Francisco and other American and European cities, selling with increasing success. Travels to France, Belgium, England and Holland. Buys a house and builds his studio.

By the end of the 1980's and beginning of the 1990's, completes his most ambitious works on the theme of the Old Testament's prophets, *Samson Destroying the House of the Philistines* (1989), *Lamentation and Mourning and Woe* (1990), *The Angel Opens the Prophet's Eyes and Mouth* (1991), *Three Deeds of Moses* (1992).

In 1992, organizes SPSF (Saint Petersburg-San Francisco), consisting of four St. Petersburg-born artists living in San Francisco. Between 1992 -1995 SPSF organizes four exhibitions of painting and photography which are enthusiastically received by Russians and Americans.

In 1992 A. R.'s first exhibition in St. Petersburg since his departure into exile is held at the St. Petersburg City Museum, and is organized by the artist's old friends with work patiently gathered from collectors and art museums.

In 1993 travels to Russia to accompany the exhibition of 15 years' work, *California Branches - Russian Roots* at the Central House of Artists on Krymsky Val, Moscow, and the Central Exhibition Hall, Manège, in St. Petersburg, organized by the Michael Dunev Gallery. This is the artist's first visit to Russia since his departure in 1976.

### 1993-1997

The last five years of his life are spent in voluntary seclusion concentrating on his own creative world. In his own words, he works not for the sake of art, but because art gives him the means to express himself. He seeks to reach out to the very core and heart of the image, an urge complemented by his ever-present inner desire to attain the ideal.

*"What I do is my way to meditate upon the themes and subjects that I care about. My work is my way of thinking."*

During these years, he produces powerful expressionistic paintings of religious themes while continuing his ongoing series Images of San Francisco. His work becomes increasingly spiritual, resembling ancient Christian art while emphasizing a spiritual unity through the continuation of a metaphysical tradition that unites both Jewish and Christian perspectives in art.

In 1995 A.R. begins an association with CIVA (Christians in Visual Arts) in Minneapolis, MN, participating in religious exhibitions and conferences.

By 1996, A.R. almost never leaves his studio, his work having become entirely introspective. Completes *Anastasis I*, his final and most personal religious work.

Travels to Paris with his wife, where they celebrate their 35th wedding anniversary.

On February 4, 1997, Alek Rapoport dies suddenly and unexpectedly in his studio, working on his new painting, *Trinity*.

M*y life... resembles the swing of a pendulum.*

*In the 1950's I attempted to break away from the academicism of the Soviet art school by turning to the western European tradition, from Titian to Cézanne. For that they named me a 'formalistic distorter.'*

*Then in the 1960's I taught my students the heritage of Russian Constructivism, the Bauhaus and Le Corbusier's Modulor. For that they incriminated me with 'ideological sabotage.'*

*In the 1970's I turned to the Byzantine-Russian icon and to the Old and New Testaments for themes. For that they stigmatized me as 'religious,' 'fascist,' and 'Zionist,' and made me leave Russia.*

*The last swing of the pendulum has brought me to the US where, in search for values lost in the fortuitous, the far-fetched and the materialistic, I turn again to the cradle of mankind – the Mediterranean area – where at the very outset of the ages the pictorial image was born. This is an art in which the Divine Spirit serves as inspiration and in which the figure of Man is both the central theme and the measure of all things.*

A. Rapoport, 1986 - 1996

THE ECUMENICAL PAINTINGS

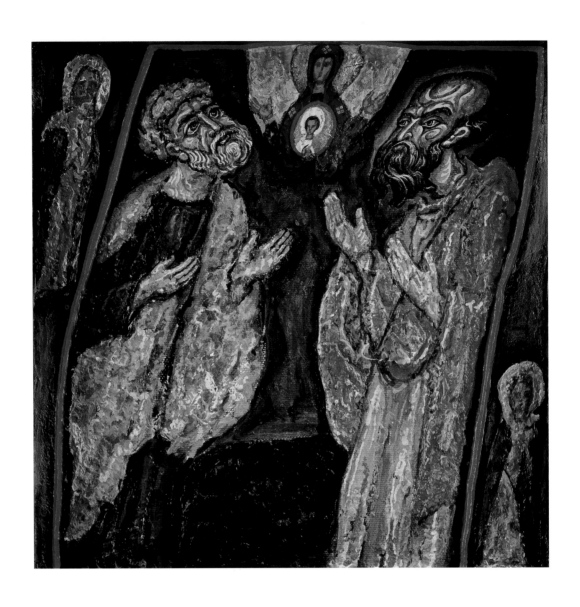

**Judeo-Christian Apostles Peter and Paul**
Relief, tempera & oil on masonite, 1995
18.5 x 20 in; 47.5 x 51 cm.
Collection I. & R. Braude, San Francisco, CA

**Jesus Christ**
(St. John 5: 17-29)
Relief, tempera
& oil on masonite, 1980
18.5 x 20 in; 47.5 x 51 cm.
Collection of the estate

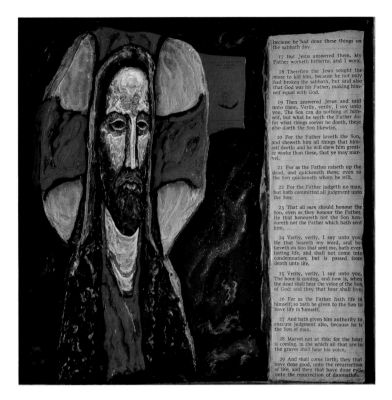

**John the Baptist and Jesus Christ**
(St. John 1: 29-36)
Relief, tempera
& oil on masonite, 1980
18.5 x 20 in; 47.5 x 51 cm.
Collection of the estate

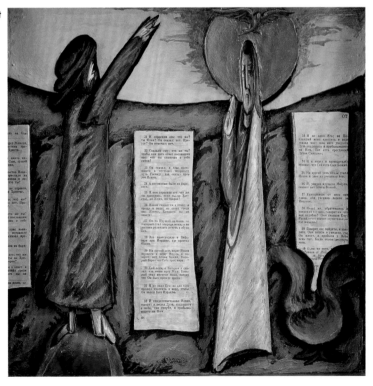

**Doubting Thomas**
(St. John 20: 27-29)
Relief, tempera & oil on masonite, 1980
18 1/2 x 20 in; 47.5 x 51 cm.
Collection I. & R. Braude, San Francisco, CA

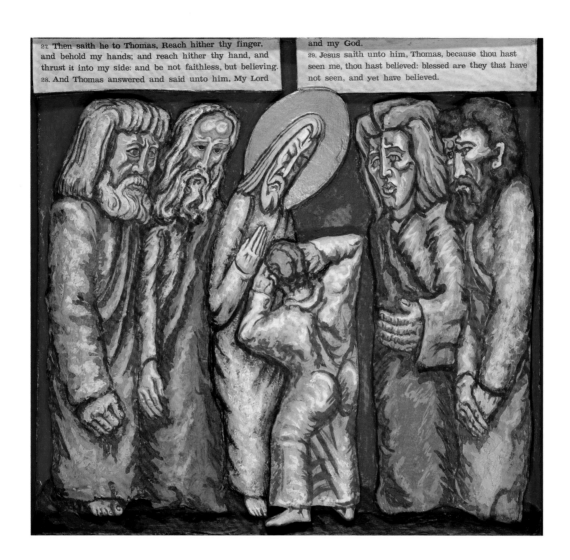

**The Short Life of Euphrosyn the Cook**
Relief, tempera & oil on masonite, 1978
42 x 42 in; 106.7 x 106.7 cm.
Private collection

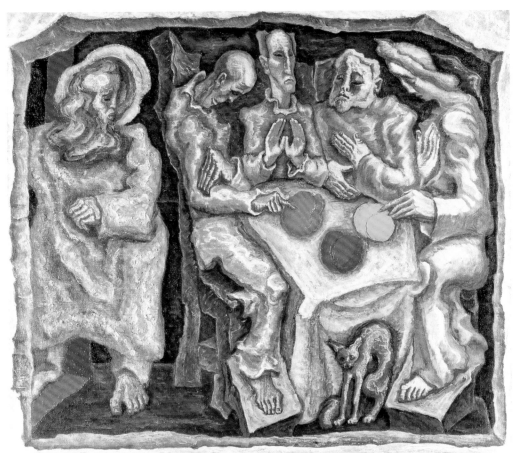

КРАТКОЕ ЖИТИЕ ЕВФРОСИНА-ПОВАРА

Памяти о. Павла Флоренского

**Deposition From the Cross in San Francisco**
Mixed media on canvas, 1982
52 x 52 in; 132 x 132 cm.
Collection R. Caruso, Denver, CO

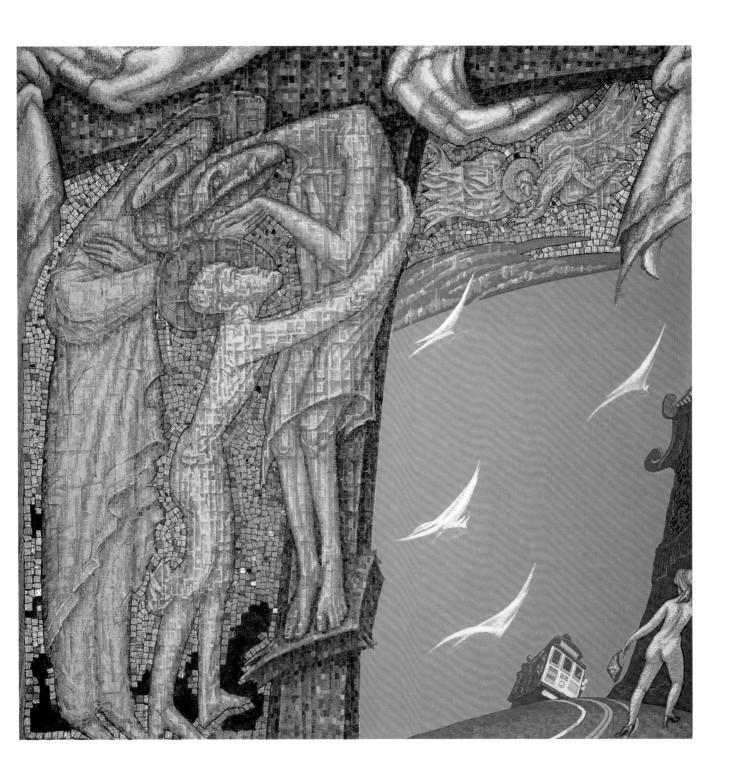

**The Lord**
(Psalm 119:89 Lamed)
Tempera & oil on canvas, 1982
52 x 52 in; 132 x 132 cm.
Collection of the estate

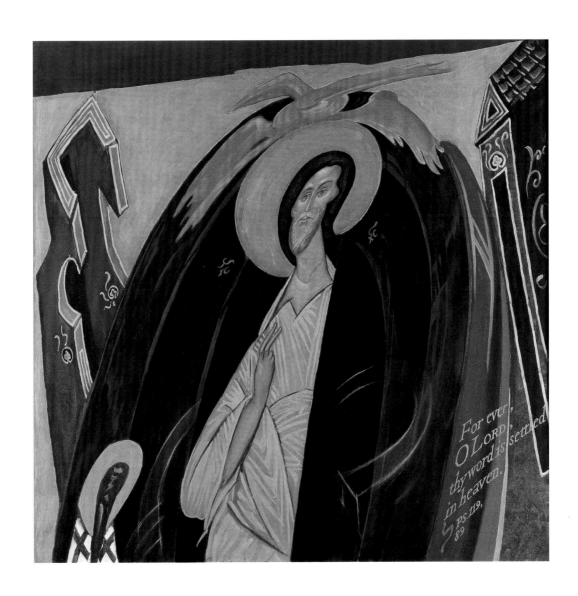

For ever,
O Lord,
thy word is settled
in heaven.
Ps. 119,
89

**Haight Street People Around the Image of Jesus Christ**
Tempera on canvas, 1984
52 x 52 in; 132 x 132 cm.
Collection V. Alexanyan & M. Migdal, Palo Alto, CA

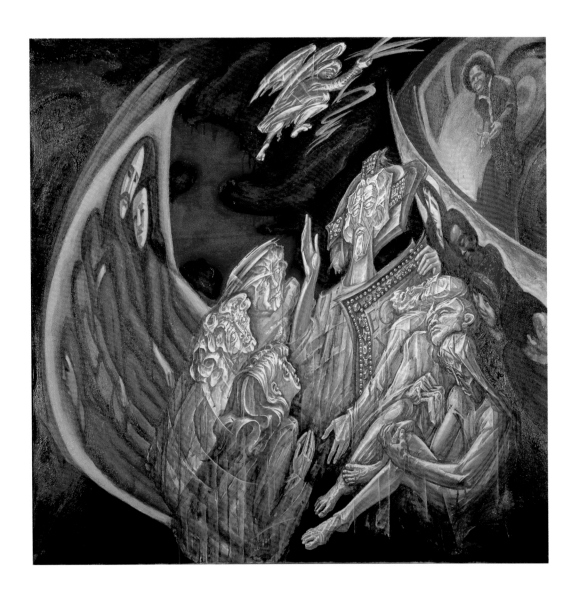

**Samson Destroying the House of the Philistines**
Relief, tempera & oil on masonite, 1989
72 x 72 1/4 in; 183 x 183.5 cm. (on two panels)
Private collection

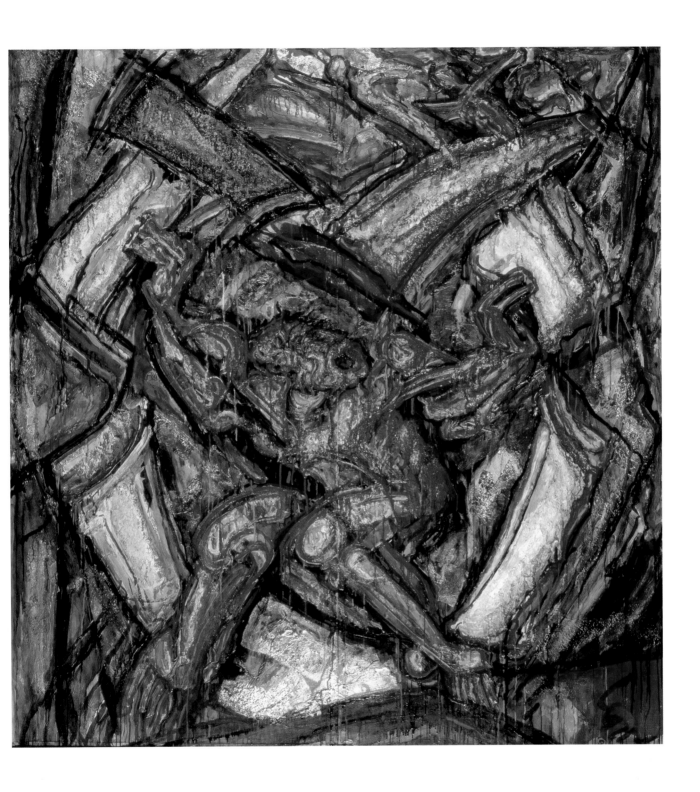

**Angel With Mask and Prophet**
Mixed media on foam board, 1990
60 x 60 in; 153 x 153 cm. (on three panels)
Collection of the estate

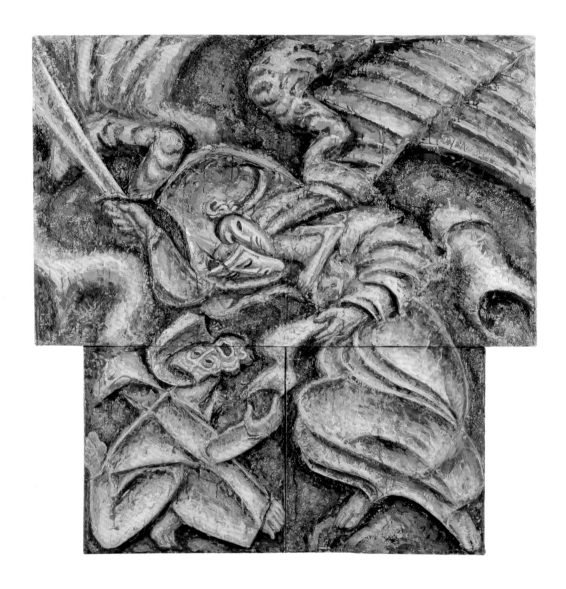

**Angel and Prophet**
(Ezekiel 2:10)
Mixed media on canvas, 1991
95 x 103 in; 241.3 x 261.6 cm. (on four panels)
Collection of the estate

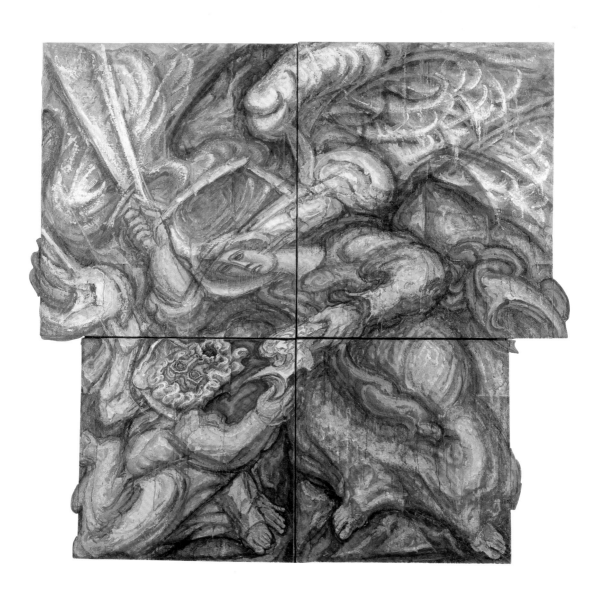

**Lamentation and Mourning and Woe**
(Ezekiel 2:10)
Relief, tempera & oil on canvas, 1990
66 x 70 in; 167.6 x 177.8 cm. (on three panels)
Collection I. & V. Rapoport

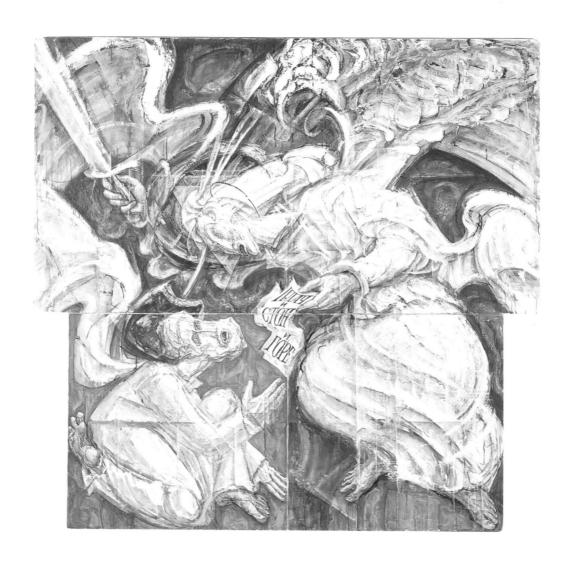

**From the Life of St. Nicholas**
Mixed media on masonite, 1991
61 x 48 1/2 in; 154 x 122.5 cm.
Collection G. & Ch. Plizga,
Brisbane, CA

**The Angel Opens The Prophet's
Eyes and Mouth**
(Daniel 10)
Relief & mixed
media on plywood, 1991
67 1/2 x 63 1/2 in;
171.5 x 161.3 cm.
(on three panels)
Collection of the estate

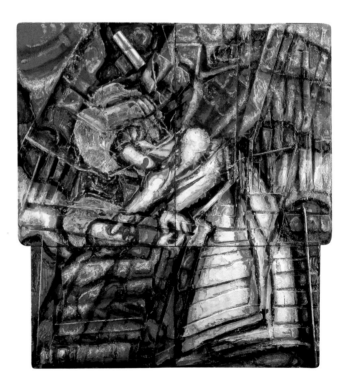

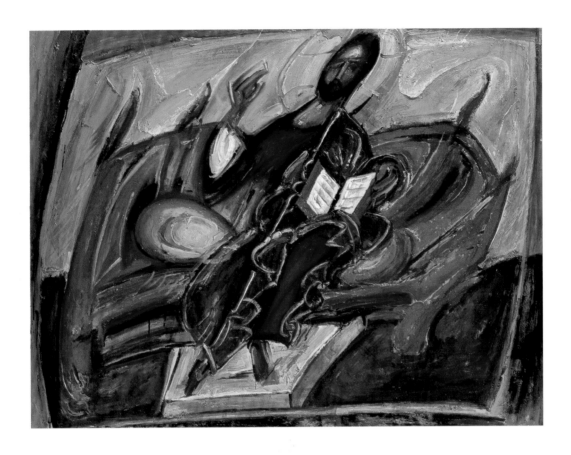

**The Image**
Mixed media on canvas, 1991
42 x 55 in; 106.5 x 139.5 cm.
Collection of the estate

**Three Deeds of Moses**
(Exodus 32:19, 20, 27)
Mixed media on canvas, 1992
102 x 84 in; 259 x 213.7 cm. (on three panels)
Collection of the estate

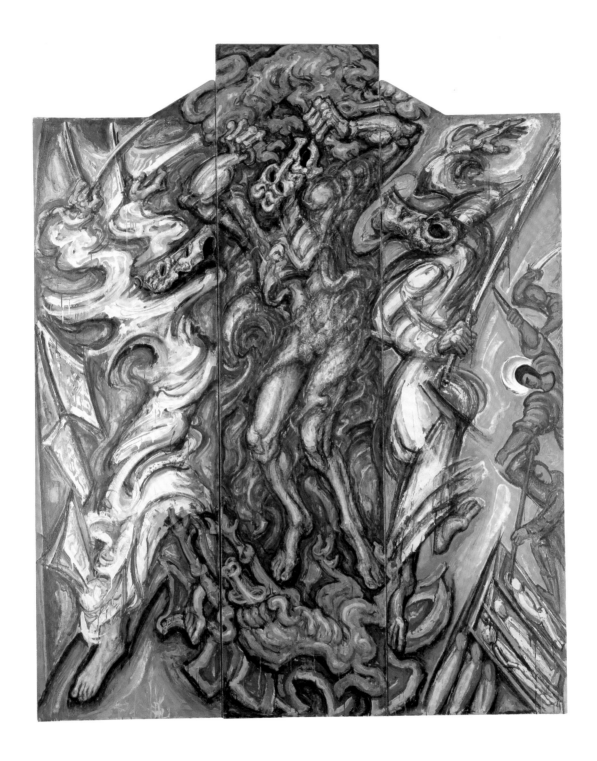

**The Incredulity of Thomas**
(St. John 20: 24-29)
Mixed media on burlap, 1993
60 x 54 in; 152.4 x 137.1 cm.
Collection V. Alexanyan & M. Migdal, Palo Alto, CA

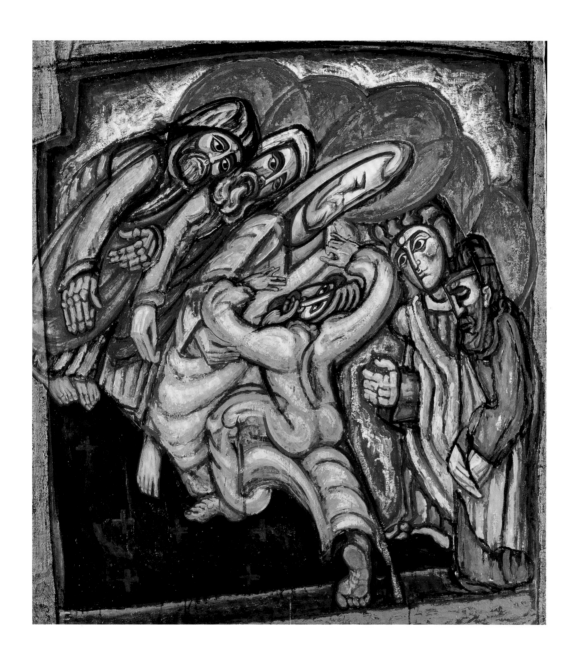

**Dormition of the Virgin With Two Apostles**
Mixed media on masonite, 1993
48 x 71 in; 122 x 181 cm. (on two panels)
Collection of the estate

**Trinity in Dark Tones**
(Genesis 18)
Tempera on cotton, 1994
48 x 63 in; 122 x 160 cm.
Collection of the estate

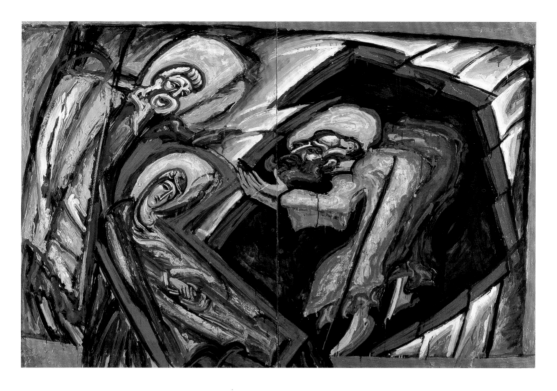

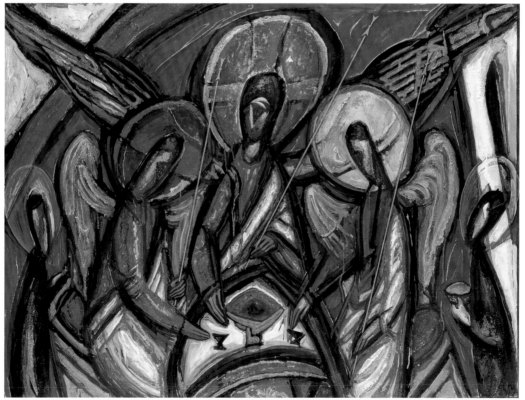

**Annunciation**
(St. Luke 1:26 - 38)
Mixed media and relief on plywood, 1995
132 x 96 x 5 in; 335 x 244 x 13 cm. (on four panels)
Collection The Marian Library,
University of Dayton, Dayton, OH

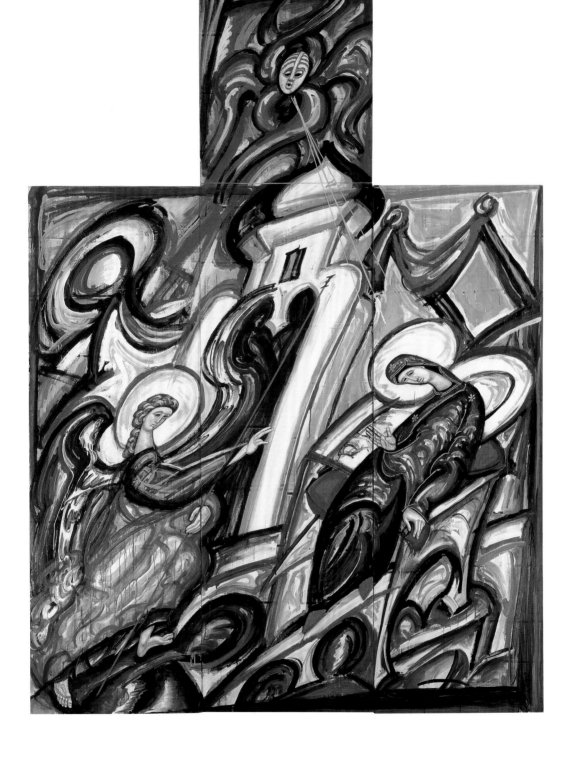

**Tres Varones en el Valle de Mamré**
(Three Men in the Plains of Mamré)
(Genesis 18: 1-15)
Mixed media on canvas, 1995
72 x 54 in; 182.8 x 137.2 cm.
Collection I. & V. Rapoport, San Francisco, CA

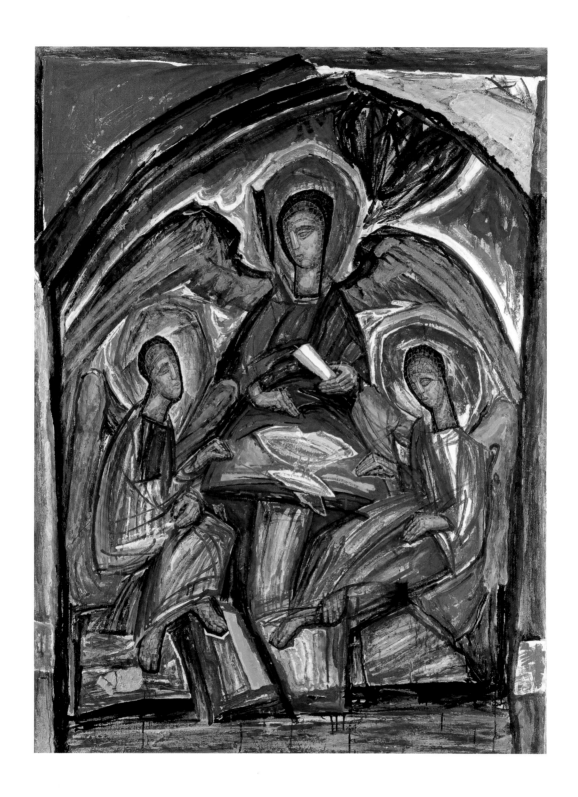

**Anastasis I**
Mixed media on burlap, 1996
72 x 48 in; 182.8 x 121.9 cm.
Collection V. Alexanyan & M. Migdal, Palo Alto, CA

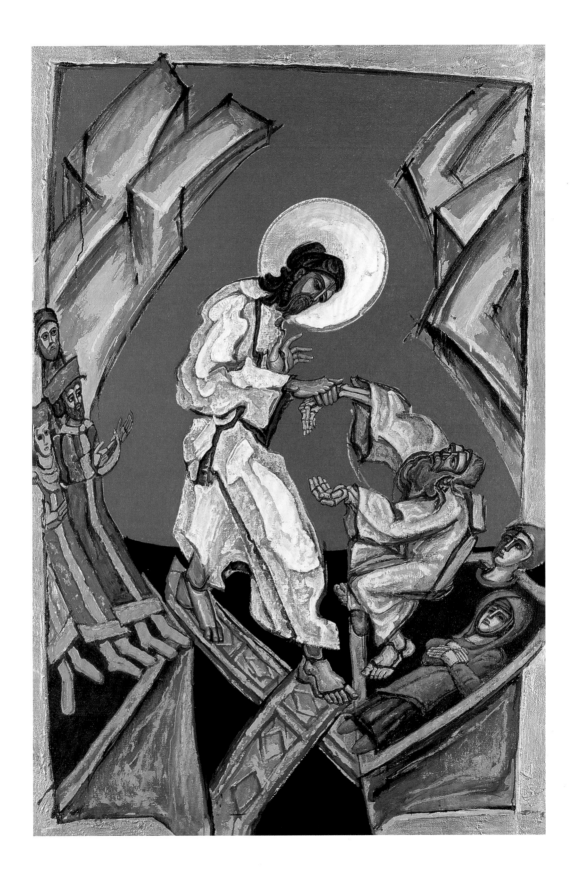

**Trinity** (unfinished painting)
Charcoal and tempera on canvas, 1997
60 x 48 in; 152.5 x 122 cm.
Collection I. & V. Rapoport, San Francisco, CA

*One may compare my religious work with a prayer in my own words as opposed to the prayers from a prayer book.*
*My art was born from the Word. I would like to believe that at least some of my "words" in turn would not "fall upon a rock" but would "fall on good ground, and spring up, and bear fruit a hundredfold." (Luke 8:8)*

A. Rapoport, 1997

THE IMAGES OF SAN FRANCISCO

**At Union Square**
Oil & gouache on pasteboard, 1983
30 x 42 in; 76 x 107 cm.
Collection of the estate

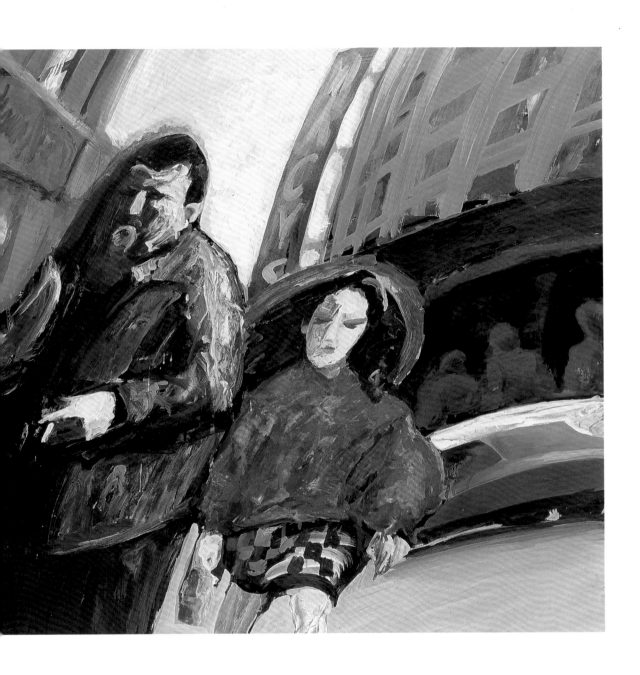

**Tramp and Yellow Car**
Oil, gouache & tempera on plywood, 1984
41 x 54 in; 104.1 x 137.1 cm. (on two panels)
Collection of the estate

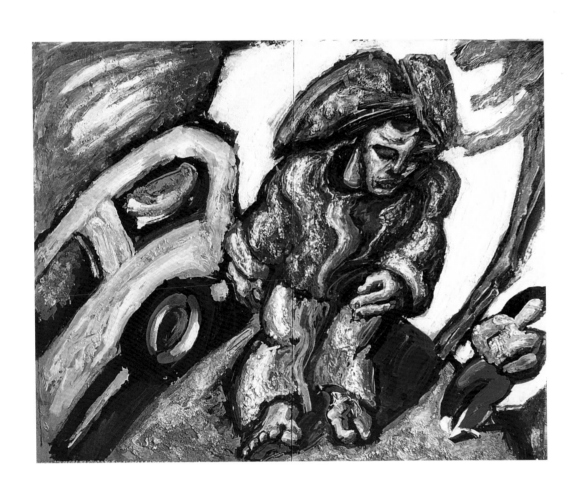

**Yellow Cabs and Warehouses**
Relief & tempera on masonite, 1986
48 x 48 in; 122 x 122 cm.
Collection N. & M. Dunev, Sausalito, CA

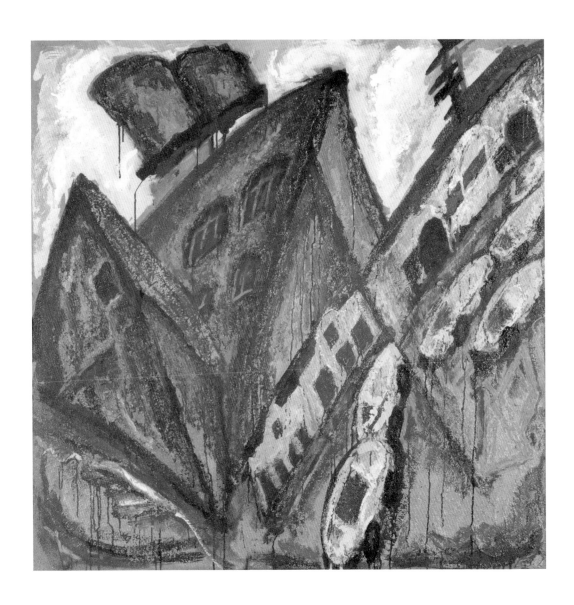

**Three Men on Market Street**
Oil & tempera on masonite, 1986
48 x 48 in; 122 x 122 cm.
Collection The Wharton School of Business,
University of Pennsylvania, Philadelphia, PA

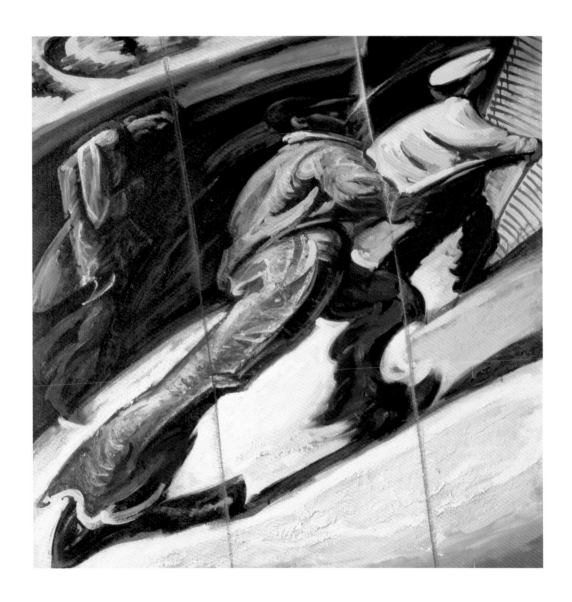

**Dos Señoritas**
Oil & Tempera on canvas, 1986
72 x 108 in; 182.8 x 274.3 cm. (on two panels)
Collection F. & S. Jardin, Berkeley, CA

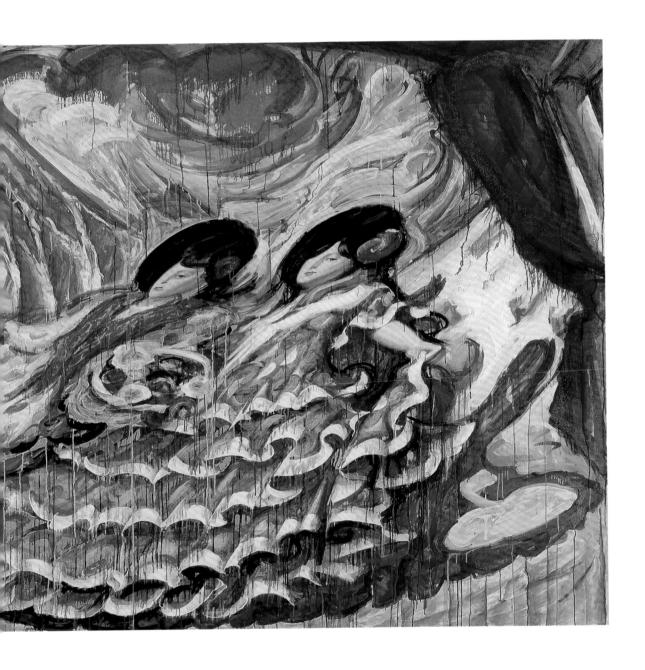

**Crossing**
Tempera on canvas, 1987
42 x 70 in; 106.5 x 178 cm.
Collection of the estate

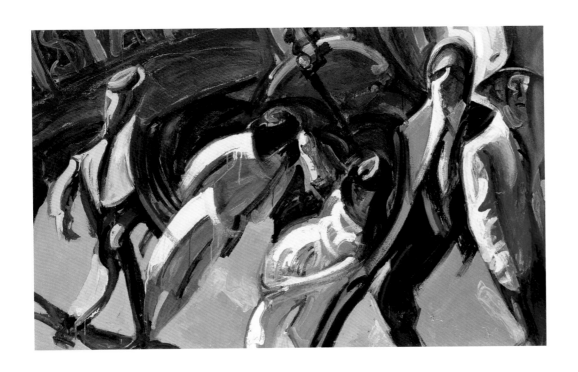

**Tourists in San Francisco (Mime)**
Mixed media on 24 canvas panels, 1990
65 x 70 in; 165 x 178 cm.
Collection I. & V. Rapoport, San Francisco, CA

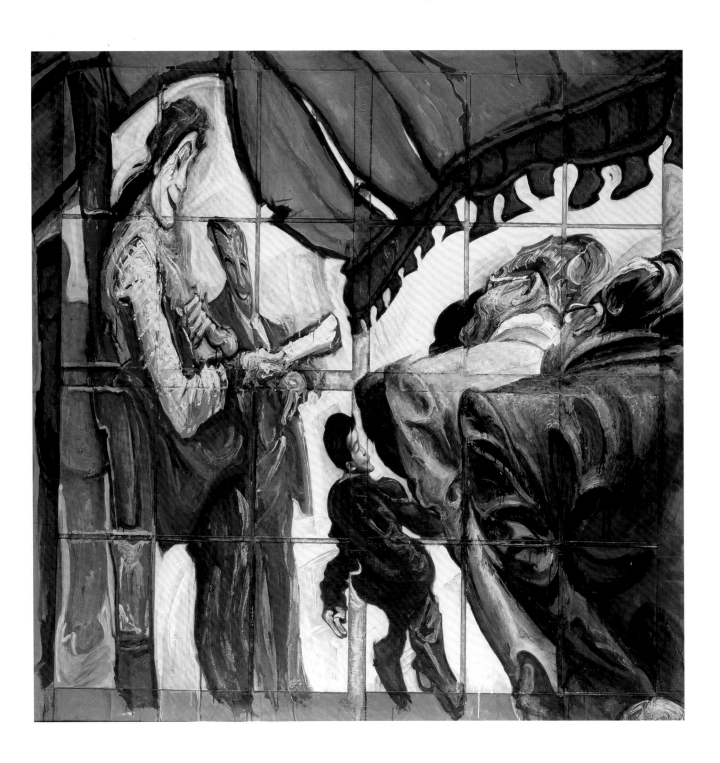

**Twenty-Four Hours**
Mixed media on burlap, 1990
47 x 50 in; 120 x 127 cm.
Collection of the estate

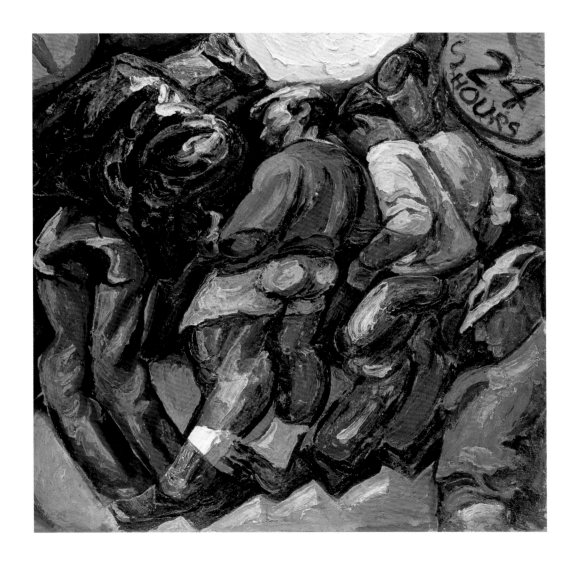

**The Curbs With Big Red San Francisco Woman**
Mixed media on burlap, 1993
72 x 121in; 182.9 x 307.3 cm. (on three panels)
Collection of the estate

**Mission Street Family**
Mixed media on burlap, 1994
50 x 61 in; 127 x 155 cm.
Collection of the estate

**Latinos on Mission Street**
Mixed media on plywood, 1994
48 x 60 in; 122 x 152.4 cm.
Collection of the estate

**Red Skirt**
Mixed media on linen, 1994
48 x 54 in; 122 x 137 cm.
Collection of the estate

**Girlfriends**
Mixed media on masonite, 1994
48 x 108 in; 122 x 274.3 cm. (on three panels)
Collection of the estate

**South of Market Warehouses**
Mixed media on burlap, 1996
60 x 71 in; 152.4 x 180.4 cm. (on two panels)
Collection of the estate

**Group of Asian Students**
Latex and pastel on paper, 1988
33 x 45 in; 83.8 x 114.3 cm.
Collection of the estate

**Images of Castro Street No. 1 (Advances on Castro Street)**
Latex and pastel on paper, 1988
33 x 45 in; 83.8 x 114.3 cm.
Collection of the estate

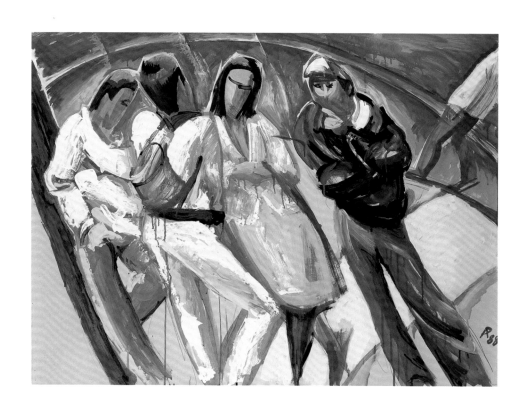

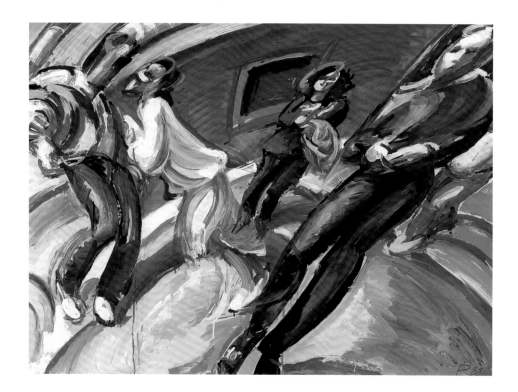

**Images of San Francisco No. 6 (With Two African American Women and a Fat Man)**
Distemper on Goznak paper, 1989
25 x 34 1/2 in; 63.5 x 87.6 cm.
Collection of the estate

**Images of Mission Street No. 7 (With Boy in Football Costume)**
Distemper on paper, 1989
25 x 31 in; 63.5 x 78.7 cm.
Collection of the estate

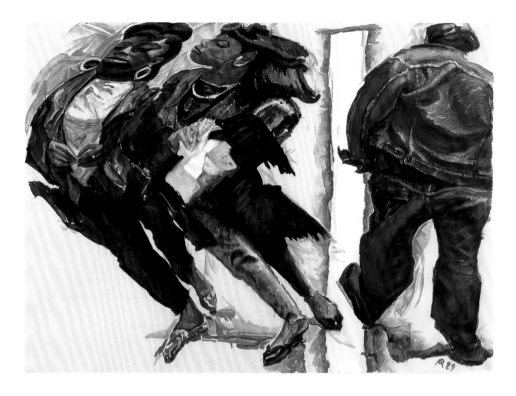

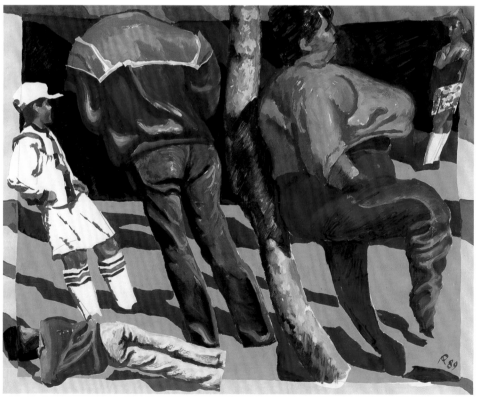

103

**Images of San Francisco No. 10 (Chinatown With an Old Chinese)**
Latex on paper, 1991
36 x 47 in; 91.4 x 119.3 cm.
Collection of the estate

**Images of Mission Street No. 12 (With Macho Man Wearing Hat)**
Latex on paper, 1992
26 x 39 in; 66 x 99 cm.
Collection of the estate

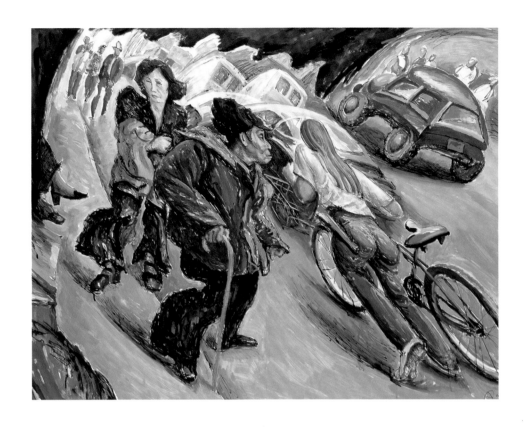

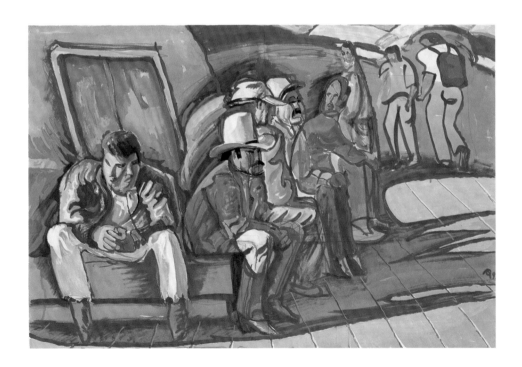

**M**y work on a particular theme resembles a living plant.

*I take the longest time developing it in geometric style.*

*This is like the roots of the plant.*

*At this stage, I may well stop.*

*However, if it works very well, I create a painted version.*
*This is the plant above the ground.*

*Then, if I feel the highest inspiration, I create a version in relief.*
*In my metaphor this is the ripe fruit, one which produces the seeds*
*of my future works.*

A. Rapoport, 1995

**Still Life With Dictionary**
Mixed media on burlap, 1982 - 1997
36 x 28 in; 91.4 x 71.1 cm.
Collection I. & V. Rapoport, San Francisco, CA

**Still Life With Dry Branches**
Tempera on canvas, 1988
36 1/2 x 24 in; 92.7 x 61 cm.
Collection M. & J. Kristul,
San Francisco, CA

**Still Life With Chinese Tea Pot**
Acrylic on cotton, 1995
24 x 17 in; 61 x 43.2 cm.
Collection A. Krichevsky,
Monterey, CA

**Still Life With Gzhel Tea Pot**
Tempera on canvas, 1984
52 x 52 in; 132 x 132 cm.
Collection E. & C. Gur-Arieh,
Piedmont, CA

# EXHIBITION HISTORY

1963   USSR Ministry of Culture, *Graduated The-ater Set Designers*, Moscow, (Merit Award).

1963-
73   Yearly state-sponsored exhibitions of stage designers, stage decorators, and costume designers, in Riga, Leningrad, Moscow, Vilnius, Kiev, USSR.

1974   TEV (Fellowship of Experimental Exhibi tions), *Exhibition of Dissident Artists*, Gaza Palace of Culture, Leningrad, USSR.

1975   TEV *Exhibition of Dissident Artists*, Nevksy Palace of Culture, Leningrad, USSR.

1975-
78   Exhibition of the ALEPH Group and *The Twelve From the Soviet Underground*, USSR (Leningrad, Moscow), USA (Los Angeles, San Francisco, Chicago, New Orleans, Detroit, Kansas City), Canada (Montreal, etc.).

1976   TEV *Exhibition of Dissident Artists*, Club "Eureka," Leningrad, USSR.

1977   *New Art From the Soviet Union*, Arts Club, Washington, DC; Herbert F. Johnson Mu seum of Art, Ithaca, NY.
*La Nuova Arte Sovietica*, Venice Biennale, Venice, Italy.
*International Exhibition of Graphic Arts*, West Germany.

1978   *Annual Arts Festival*, San Francisco, CA.

1979   *Moscow-Paris*, C.A.S.E., Montgeron, France.
Galerie "Slavia," Bremen, West Germany.

1980   *Nicht-offiziele Kunst aus Russland*, (Vienna, Bregenz, Salzburg), Austria.
Gallerie "Trifalco," Rome, Italy.
*Beyond the Looking Glass: The Other Art of Russia*, Saulsbury Gallery, Temple, Texas; San Antonio Art Institute, San Antonio, TX.

1981   Nanny Goat Hill Gallery, San Francisco, CA.
*50 Years of Russian Art in the USA*, Los An geles University, Los Angeles, CA.
"Galerie in der Kartause Gaming," Vienna, Austria.
*Images of San Francisco*, Eduard Nakhamkin Gallery, New York, NY.

1982 *Russian Art in Exile*, Park Lane Gallery, New York, NY.
*Russian Religious Art at the Jersey City Museum of Soviet Unofficial Art*, Jersey City, NJ.
*Image and Color*, The Sloane Gallery, Denver, CO.

1983 US Senate Exhibition of Russian Art, Washington, DC.
*Religious Paintings at the Burlingame Mercy Center*, Burlingame, CA.

1984 *Contemporary Russian Art*, the G. Janecek Collection, University of Kentucky, Raskell Gallery, Lexington, KY.
*Images of San Francisco*, University of the Pacific Gallery, Stockton, CA.

1985 *Recent Acquisitions*, Museum of Russian Contemporary Art in Exile, Jersey City, NJ.
*IX Biennial Exhibition of Liturgical Art*, Columbus, OH.
*San Francisco 39th Annual Arts Festival*, SF Art Institute, Fort Mason Center, San Francisco, CA.

1986 Michael Dunev Fine Arts, San Francisco, CA.
*All California on a Small Scale*, Laguna Art Museum, Laguna Beach, CA, (Award).
*Visions of God*, St. Joseph's Parish, Redding, CA, (Award).
*Bay Area Seen II*, San Mateo Arts Council, San Mateo, CA.
*Art Against Hunger, The Lent Show* Gallery Sanchez, San Francisco, CA.
*Erotic 86*, North West Artists Workshop, Portland, OR.
*Ninth Annual Art Auction at Creative Growth Art Center*, Oakland, CA.
*San Francisco Then and Now*, Jan Holloway Gallery, San Francisco, CA.

1987 Michael Dunev Fine Arts, San Francisco, CA.
*Jewish Themes*, The Judah L. Magnes Museum, Berkeley, CA.
*The Art of the Russian Émigré*, Koret Gallery, Jewish Community Center, Palo Alto, CA.
Southern Exposure Gallery, San Francisco, CA.
Elizabeth S. Fine Museum, San Francisco, CA.

1988 Michael Dunev Gallery, San Francisco, CA.
Burlingame Mercy Center, *Mythological and Ecumenical Works*, Burlingame, CA.
*The San Jose Liturgical Festival*, Santa Clara Convention Center, Santa Clara, CA.
*The Ties That Bind*, Michael Dunev Gallery, San Francisco, CA.
*Contemporary Art Abroad*, Manège, Leningrad, USSR.
*Floral Extravaganza*, San Francisco Annual Art Festival, Hall of Flowers, San Francisco, CA.
*Freedom and Creation*, Norman Brown Art Gallery, Baltimore, MD.

1989 *The Purim Mask*, The Jewish Community Museum, San Francisco, CA.
The New Chinese American Cultural Center, San Francisco, CA.
*Salute to Flowers*, San Francisco County Arts Festival, San Francisco, CA.
*Art for Peace*, East West Art Center, San Francisco, CA.
*Cityscapes*, Michael Dunev Gallery, San Francisco, CA.
*Creativity Under Duress*, Exhibition of The ALEPH Group (travelling exhibition), Louisville, KY.

1990 Michael Dunev Gallery, San Francisco, CA.

1991-
93 *Images of American Immigration*, INS Centennial Art Contest, Georgetown University, Washington, DC; R. Reagan Memorial Library, Simi Valley, CA; Museum of Natural History, Los Angeles, CA; Ellis Island Museum, NY; Transamerica Pyramid, San Francisco, CA, (National Award - Third Prize).

1992 *Old Voices - New Faces*, B'nai B'rith Klutznick National Jewish Museum, Washington, DC.
*Expectation of a Miracle: Russian Art at Home and Abroad*, One Market Plaza, San Francisco, CA.
*Identities Lost and Found: Russian Jewish Artists from the 1920s - 1990s*, One Bush Street, San Francisco, CA.
*Second Annual Art Show*, Bernard Osher Marin Jewish Community Center, San Rafael, CA.
*Russia - USA*, The Museum of the City of St. Petersburg, St. Petersburg, Russia.

1993 *About Face*, The Jewish Museum, San Francisco, CA.
*California Branches, Russian Roots*, Manège Exhibition Hall, St. Petersburg, Russia; National Exhibition Hall, Moscow, Russia.
*St. Petersburg - San Francisco Group*, Eight Street Gallery, Berkeley, CA.

1994 *Guardians, Spirits & Messengers: The Angel in Contemporary Art*, The Pope Gallery, Santa Cruz, CA.
*Splinters of a Collapsed Colossus*, OPTS Gallery, San Francisco, CA.

1995 Group exhibition, George Krevsky Fine Arts, San Francisco, CA.
*St. Petersburg - San Francisco Group*, Belcher Studios Gallery, San Francisco, CA.
*Who Controls Public Space?*, SOMAR Gallery, San Francisco, CA.

*Ecumenical Paintings*, Michael Dunev Gallery, San Francisco, CA.
*Art and the Holocaust*, B'nai B'rith Klutznick National Jewish Museum, Washington, DC.
*Eight Contemporary Russians*, Chetwynd Stapylton Gallery, Portland, OR.
*El Dia de los Muertos, Life and Death: Crossing Frontiers*, SOMAR Gallery, San Francisco, CA.
*Works of Faith*, Georgia-Ann Gregory Gallery One, Mendocino, CA.
*Icon Influences*, The Visions Gallery, Albany, NY.
*From Gulag to Glasnost: Nonconformist Art from the Soviet Union, 1956-1986: The Nancy and Norton Dodge Collection*, The Jane Voorhees Zimmerli Art Museum, Rutgers, The State University of New Jersey, New Brunswick, NJ.

1996 Group exhibition, George Krevsky Fine Arts, San Francisco, CA.
*Ecumenical Work*, SOMAR Gallery, San Francisco, CA.
*Behold the Lamb: The Life of Christ*, The Biblical Arts Center, Dallas, TX.
*Sacred Arts*, Billy Graham Center Museum, Wheaton College, Wheaton, IL.

1997 *The Last Paintings: A Memorial Exhibition*, Michael Dunev Gallery, San Francisco, CA.
*The Early Drawings: A Memorial Exhibition*, George Krevsky Fine Art, San Francisco, CA.
*Nanny Goat Hill Redux*, SOMAR Gallery, San Francisco, CA.
*In Focus: The Paintings of Alek Rapoport*, Duke University Museum of Art, Durham, NC.

1997 *Sacred Inspiration: Icons by Alek Rapoport*, The Marian Library, IMRI, Dayton University, Dayton, OH.
*Things to Think On Exhibition*, The Merrick Free Art Gallery, New Brighton, PA.
*The Many Faces of Faith*, Balch Institute for Ethnic Studies, Philadelphia, PA.

## SELECTED PUBLIC COLLECTIONS

Apostolic Nunciature to the USA, Washington, DC
Archdiocese of San Francisco, CA
The Art Museum of Khabarovsk, Russia
Duke University Museum of Art, Duke University, Durham, NC
His Holiness Pope John Paul II, Vatican City
INS Collection, US Government, Ellis Island Museum, NY
International Marian Research Institute and The Marian Library, Dayton University, Dayton, OH
The Jane V. Zimmerli Art Museum, Rutgers, The State University of New Jersey, New Brunswick, NJ
Kaiser-Permanente Hospital, San Francisco, CA
The J. L. Magnes Memorial Museum, Berkeley, CA
Manege Museum of Contemporary Art, St. Petersburg, Russia
McDonald's Corporation, Sacramento, CA
Mercy Center, Burlingame, CA
Museum of the City of St. Petersburg, St. Petersburg, Russia
Museum of Russian Art in Exile, Montgeron, France
Museum of Soviet Unofficial Art, Jersey City, NJ
Museum of State Institute of Theater, Music and Cinematography, St. Petersburg, Russia
State Russian Museum, St. Petersburg, Collection of A. G. Ender
The Wharton School of Business, University of Pennsylvania, Philadelphia, PA

**Portrait of Vladimir as a Young Man**
Tempera on canvas, 1993
50 x 36 in; 127 x 91.5 cm.
Collection I. & V. Rapoport, San Francisco, CA

# BIBLIOGRAPHY

1963    Uvarova, I., *The Theater Planet of the Artists*, "Soviet Culture," August, Moscow.

1975    Katzevman, A., *Everything is Not Equally Good*, "Soviet Economist," N. 36 (241), November 19, Leningrad.

1976    Destefano, G., *Visions from the Soviet Underground*, "Fair Press," October 6, Westport.

Dodge, N., *New Art From the Soviet Union*, catalog, St. Louis.

Donch, T., *Repression of the Arts*, "Art for Humanity," Fall issue.

Eliezer, R., *First Exhibition of Jewish Artists in Leningrad*, "Nasha Strana," November 12, Tel Aviv.

SF Bay Area Council on Soviet Jewry, *Twelve From the Soviet Underground*, Judah L. Magnes Museum, Berkeley, CA, catalog.

1977    Chernobelsky, L., *The Pictures from the Exhibition, Jews in the USSR*, N12, January - March, Moscow; "Nasha Strana," Tel Aviv.

Crispolti, E., Moncada, G., *La Nuova Arte Sovietica* - La Biennale Di Venezia, Venice, catalog.

Dean, S., *Soviet Artist Fought To Defy Censorship*, "Tucson Citizen," September 16, Tucson, AZ.

Dodge, N., Hilton, A., *New Art from the Soviet Union*, Washington, DC, catalog.

Frankenstein, A., *Out of Russia*, San Francisco Chronicle/Examiner, August.

Grieg, M., *S.F.'s Russian Art Show Draws a Rival*, San Francisco Chronicle, August 6.

Nechaev, V., Nedrobova, M., *Rebellion on the Canvas*, "Vremia I My," N18, June, Tel Aviv.

1977 "The Temple Congregation B'nai Jehudah Bulletin," December 28, Kansas City, KS.

"La Voce Republicana," *Queste opere sono 'Anti Sovietiche,'* March 15, Rome.

**Rapoport, A.,** *A Soviet Non-Conformist Artist Speaks Out,* "California Living" September, San Francisco, CA.

————— ., *About the Exhibition of Russian and Soviet Art at the M. H. de Young Museum,* "Possev," N 9 (1244), September, Frankfurt am Main; "Russian Life," N8720, August 24, San Francisco, CA; "Novoye Russkoye Slovo," August 17, New York.

————— ., *Ecco Cos'e in URSS La Dissidenza in Arte,* "Shalom" N4, Rome.

**Tully, J.,** *Underground Soviet Art at Museum,* "The Arizona Daily Star," September 14, Tucson, AZ.

1978 **Ashley, L.,** *Art by Soviet Underground to Southfield,* "The Detroit News," May 10, Detroit, MI.

**Dunn, M.,** *Painter Harassed by Soviets,* "The Kansas City Times," January 12, Kansas City, KS.

**Goldman, J. M.,** *Photo-Murals Show Art of Dissident Soviet Jews,* "The Daily Tribune," May 8, Royal Oak, MI.

**Hillbish, J.,** *Banned Russian Works Will Hang at Art Institute,* "The Repository," March 24, Canton, OH.

**Iden, S.,** *Underground Artists Play Russian Roulette,* "Southfield," May 11, Detroit, MI.

**Shapiro, A.,** *Russian Jewish Artist Visits City, Shows "Underground" Art,* "Kansas City Chronicle Playbill," January 13, Kansas City, KS.

1979 **Liebert, L.,** *How Russian Jews Find Life in the Bay Area,* "San Francisco Chronicle, September 3, San Francisco, CA.

**Rapoport, A.,** *The Last Exhibitions (In Memory of Sasha Arefiev),* "Novoye Russkoye Slovo," November 9, New York.

1980 **Bowlt, J., Kuzminsky, K.,** *Beyond the Looking Glass: The Other Art of Russia,* Cultural Activities Center, Saulsbury Gallery, Temple, TX, catalog.

**Glezer, A.,** *Museum of Soviet Unofficial Art,* C.A.S.E., Jersey City, NJ, catalog.

**Miele, F.,** *Rapoport & Rabinovich,* Galleria Trifalco, Rome, catalog.

**Petrovsky, V.,** *About God, Art and a Man,* "Vremia I My," N56, September - October, New York, Tel Aviv, Paris.

**Simongini, F.,** *La Pittura del Dessenso,* "Il Tempo," N125, May, Rome.

1981 **Aleksandrov, P.,** *Alek Rapoport,* "Novoye Russkoye Slovo," November, New York.

**Freeman, R.,** *Alek Rapoport,* Berkeley Creators Association Leaflet, Berkeley, CA.

**Rapoport, A.,** Scythian Publishing, Oakland, CA.

**Veitsman, Z., Stolina, M.,** *Alek Rapoport - the Artist - Nonoconformist,* "New Life," N11, March 11, San Francisco, CA.

1983 *Unofficial Art from the Soviet Union,* catalog for US Senate exhibition.

**Krichevsky, P.,** *Spiritual Art,* "Novoye Russkoye Slovo," October 9, New York.

1984 *Dissident Russian Artist's Works on Display at UOP,* "The Stockton Record," November 4, Stockton, CA.

"Modern Liturgy," Vol. 11, N6, September, San Jose, CA.

*National Forum on Worship Environment and the Arts,* San Francisco, CA, catalog.

1984    Ernst, M., *Gallery Offers Artistic Tour of San Francisco*, "The Stockton Record," November 11, Stockton, CA.

Lawrence, A., *Russian Rapoport Displays Works*, "The Pacifican," November 15, Stockton, CA.

1985    "Modern Liturgy," Vol. 12, N6, September, San Jose, CA.

IX Biennial Exhibition Catalog, *The Liturgical Art Guild of Ohio*, Worthington, OH.

*Recent Acquisitions from the Collection of the C.A.S.E.*, Jersey City, New Jersey, catalog.

1986    Laguna Art Museum, Laguna Beach, CA, *All California on a Small Scale*, catalog.

Baker, K., *Funhouse Effect in Illusionistic Paintings*, "San Francisco Chronicle," July 25.

Glezer, A., *The Way of Alek Rapoport*, "Novoye Russkoye Slovo," January 10, New York.

————., *Russian Artists in the West*, "Third Wave Publishing House," Paris - New York.

Lemkhin, M., *To Remain by Him self*, "New Life," N75-76, September - October, San Francisco, CA

Scharlach, B., *California Dreaming*, "Hadassah Magazine," Vol. 68, N4, December, New York.

Shere, C., *Introductions Presents a Diversity of Young Talent*, "The Tribune," July 15, Oakland, CA.

1987    "Artnews," Vol. 86, N6, Summer, New York.

"The Northern California Jewish Bulletin," *Jewish Artist to Exhibit Underground Works at ALSJCC*, September 4, Palo Alto, CA.

"ZYZZYVA," Vol. III, N3, Fall, San Francisco, CA.

Judah L. Magnes Museum, *Jewish Themes: Northern California Artists*, Berkeley, CA, catalog.

Kaufman, T., *Jewish Themes Inspire Creative Outpouring at the Magnes*, "The Northern California Jewish Bulletin," February 20, San Francisco, CA.

Koret Gallery, *Gallery Spotlights Refusenik's Work*, "Centerpiece," Jewish Community Center, Vol. 5, N2, September, Palo Alto, CA.

Rapoport, A., *In Memory of Sasha Arefiev*, "New Life," N86-87, August-September, San Francisco, CA.

1988    "Encyclopedia of Living Artists in America: An Illustrated Guide to Current Art in America," Renaissance, CA.

Rapoport, A., *Real'naia estatnost' Panteleia Rekvizitova*, "Vetcherniy Zvon," N26, "Vivrizm," Paris.

1989    Basin, A., *GAZANEVSHCHINA*, 1974-1989, Leningrad, Jerusalem.

Garron, L., Arnow, J., *Creativity Under Duress: From Gulag to Glasnost*, the ALEF Group, Louisville, KY, catalog.

Lemkhin, M., McDonald, J., *Positive Negatives: A. Rapoport - A Biography*, "St. John's College," Santa Fe, NM.

Nuttman, S.M., C. *Art In The Center*, "Mercy Center Newsletter," Vol. 7, N2, Burlingame, CA.

Rapoport, A. , *How 'Dada' School Was Set and Developed in Northern California*, "New Life," N113, December, San Francisco, CA.

1990    Andreeva, E., *The Artists of Gazanevshchina*, Leningrad.

Rapoport, A., *Three Encounters With Komar and Melamid or Phenomenon KM*, "Muleta-Z," Vivrizm, Paris.

Solovieva, R., Manusov, A., *Snova 'ALEF*,' "*VEK* (Herald of Jewish Culture)," N2(5), Riga, Latvia.

1992 "Bernard Osher Marin Jewish Community Center," San Rafael, CA, catalog.

Trofimenkov, M., *Velikoe Sidenie*, "Smena," N242, October 19, Leningrad.

Soltes, O., *Old Voices, New Faces: Jewish Artists from the 1920s-1990s*, "B'nai B'rith Klutznick National Jewish Museum, Washington, DC, catalog.

Trofimenkov, M., *Alek Rapoport at the Museum of the History of St. Petersburg*, December, St. Petersburg,

Yudin, C., "*St. Petersburg - San Francisco*, "Novoye Russkoye Slovo," December 28, New York.

1993 *Images of American Immigration*, The Transamerica Pyramid, San Francisco, CA, catalog.

Ianenko, O., *Dialog-eto vam ne Diogen v bochke*, (Review of Manège Exhibition), "Nord-West," N5, July, St. Petersburg.

Lemkhin, M., *The Images of Emigration*, "Panorama," N620, Los Angeles, CA.

Levengarts, V., *Homecoming: To the Rapoport Exhibition at the Museum of the History of St. Petersburg*, "AMI, Narod moi," N5(58), March 15, St. Petersburg.

Santiago, C., *Russian Artist's 'Images' Shown in San Francisco*, "The Oakland Tribune," January 18, Oakland, CA.

1994 Lemkhin, M., *Oskolki Razbitogo Kolossa*, "Panorama," N709, November 9-14, Los Angeles, CA.

Rapoport, A., *How I Achieved Success in America: Humorous and Ironic Short Story*, "New Life," N167, December, San Francisco, CA.

————. , *Russian Roots, California Branches*, Manège Museum of Contemporary Art, St. Petersburg, catalog.

1995 Baranovksy, V., *Iz Provintsii Vidnee*, "Novoye Russkoye Slovo," February 28, New York.

Bowden, S., *Icon Influences*, Visions Gallery, Albany, NY, catalog.

Dodge, N., Rosenfeld, A., *From Gulag to Glasnost: Nonconformist Art in the Soviet Union*, J. V. Zimmerli Art Museum, Rutgers, the State University of New Jersey, Brunswick, NJ, catalog.

Jana, R., *Russian Artists at OPTS Art*, Asian Art News, Vol. 5, N1, January-February, San Francisco, CA.

Petrenko, M., *Piatero iz Pitera*, "Panorama," N726, March 8-14, Los Angeles, CA.

Soltes, O., *Revolution and Renovation: Art and the Holocaust*, B'nai B'rith Klutznick National Jewish Museum, Washington, DC, catalog.

1996 Lemkhin, M., *Alek Rapoport at SOMA Gallery*, "Novoye Russkoye Slovo," February 20, New York; "Russkaya Mysl," N4123, April - May, Paris.

1997 Balch Institute for Ethnic Studies, *Art & Religion: The Many Faces of Faith*, "Villanova University Art Gallery," July 1 - August 22, Philadelphia, PA, catalog.

CIVA, *Things to Think On*, Merrick Art Gallery, May 4-25, New Brighton, PA, catalog.

Colman, S., *Ex-Soviet Artist Did What He Loved to Do Until the End*, "Jewish Bulletin of Northern California," May 23, San Francisco, CA.

Lemkhin, M., *In Memory of Alek Rapoport*, "Russkaya Mysl," N4162, February 20 - 26, Paris.

————., *Without Alek*, "Novoye Russkoye Slovo," February 19, New York.

**1997** The Marian Library/International Marian Research Institute, *Sacred Inspiration: Icons by Alek Rapoport,* University of Dayton, Dayton, OH.

**Levintov, A.**, *The Quiet Genius of a Troubled World,* "Panorama," N827, February 12-18, Los Angeles, "Kstatie," N113, San Francisco, Sacramento, CA.

————., *The Way,* "Kstatie," N127, May 19-25, San Francisco, Sacramento, CA.

**Mezzatesta, M.**, *In Focus: The Paintings of Alek Rapoport,* Fall 1997 - Summer 1998, DUMA, Duke University Museum of Art, Durham, NC, catalog.

**Rapoport, A.**, *Traditions and Innovations in the Visual Arts,* (unpublished).

**Vlasenko, G.**, *In Memory of Alek Rapoport,* "New Life," N192, March, San Francisco, CA.

**Portrait of Son**
Tempera on plywood, 1973
22 x 18 in; 55 x 44 cm.
Coll. I. & V. Rapoport, San Francisco, CA

# INDEX OF ILLUSTRATIONS

### IN THE MIDDLE OF THE ROAD

In the middle of the road there was a stone
there was a stone in the middle of the road
there was a stone
in the middle of the road there was a stone.

Never should I forget this event
in the life of my fatigued retinas.
Never should I forget that in the middle of the road
there was a stone
there was a stone in the middle of the road
in the middle of the road there was a stone.

Carlos Drummond de Andrade (1902 - 1987)